Jacob Lawrence

Thirty Years of Prints
(1963–1993)

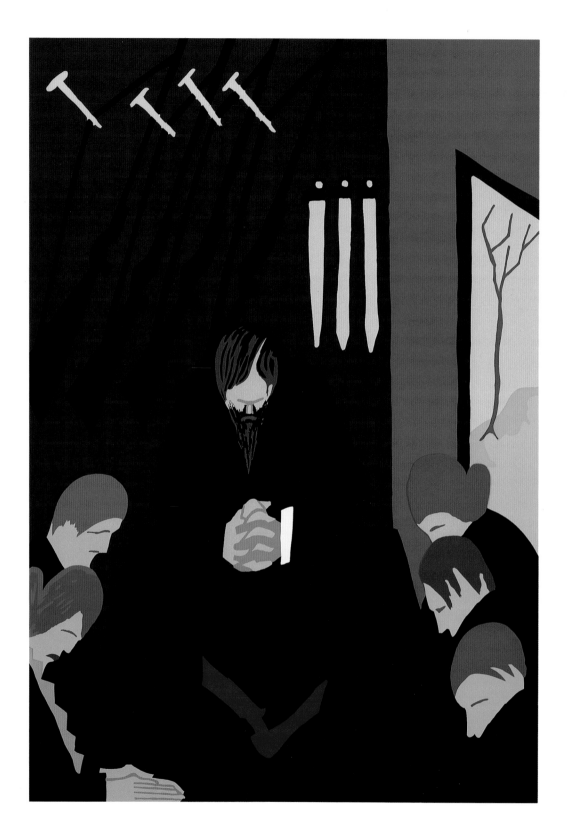

Jacob Lawrence

Thirty Years of Prints
(1963–1993)
A Catalogue Raisonné

Essay by Patricia Hills

Edited with an introduction and catalogue
by Peter Nesbett

Francine Seders Gallery Ltd., Seattle

in association with
University of Washington Press
Seattle and London

Published on the occasion of a nationally touring exhibition
Jacob Lawrence: Thirty Years of Prints (1963–1993), sponsored by
Bellevue Art Museum, Bellevue, Washington.

Jacob Lawrence: Thirty Years of Prints (1963–1993)
A Catalogue Raisonné

ISBN 0-295-97357-9

Distributed by University of Washington Press
P.O. Box 50096, Seattle, Washington 98145-5096

Produced by Marquand Books, Inc., Seattle
Designed by Ed Marquand
Text edited by Marie Weiler
Printed and bound in Hong Kong

Cover: *The Library,* 1978
Back cover: No. 5 from The Legend of John Brown portfolio, 1977
Frontispiece: No. 2 from The Legend of John Brown portfolio, 1977
Page 14: No. 6 from Eight Studies for the Book of Genesis portfolio,
1990

All photographs by Spike Mafford, Seattle, except the following:
page 8 by John T. Hill; pages 12 (left) and 13 (left) by Dennis R.
Whitehead, courtesy the Amistad Research Center, New Orleans;
pages 38–40, 42–44, and 50–51 by Chris Eden, Seattle.

The author gratefully acknowledges the following for permission
to reproduce quotations by the artist:
Bonnie Hoppin. "Arts Interview: Jacob Lawrence," *Puget Soundings,*
February 1977. (Pages 28, 29)
Kent Bicentennial Portfolio: Spirit of Independence. New York: Lorillard,
a Division of Loews Theatres, 1975. (Page 30)
Jacob Lawrence. *Harriet and the Promised Land.* 1968; reprint, New
York: Simon & Schuster, 1993. (Page 23)
The Legend of John Brown. Detroit: Detroit Institute of Arts, 1978.
(Page 38)
Ellen Harkins Wheat. *Jacob Lawrence: American Painter.* Seattle:
Seattle Art Museum and University of Washington Press, 1986.
(Page 34)

The following pages include quotations by Jacob Lawrence excerpted
from interviews with the author between June and November 1993:
22, 31, 32, 33, 44, 47, 54, 55.

The following pages include quotations by Jacob Lawrence excerpted
from a lecture at Henry Art Gallery, University of Washington, Seattle,
August 12, 1993: 27, 36, 37, 41, 46, 50.

The following pages include quotations by Jacob Lawrence excerpted
from written statements, courtesy Francine Seders Gallery: 42
(October 11, 1992), 49 (April 26, 1991).

Contents

Acknowledgments

No catalogue raisonné of an artist's work can be done with-out the help of many individuals. When we started assembling information for the catalogue of all the prints created by Jacob Lawrence through 1993, I thought it would be an easy task, since the majority were executed within the last twenty years. I soon realized, however, that a lot of information was not readily available: workshops had closed, printers had passed away, and information on paper used and on publishers was somewhat uncertain. Filling in the gaps necessitated contacting many people, whom I want to acknowledge here.

Master Printers Kent Lovelace, of Stone Press Editions, Seattle, and Lou Stovall, of Workshop, Inc., Washington, D.C., were extremely helpful with technical questions. I would also like to thank the many other printers who provided us with information: Steven Miller, George C. Miller & Son, Chestnut Ridge, New York; Allan Edmunds, Brandywine Workshop, Philadelphia; Joseph Kleineman and Maureen Turci, JK Fine Art Editions, Union City, New Jersey; Alexander Heinrici, Studio Heinrici, New York; Xavier H. Rivera, Soho Graphic Arts Workshop, New York; George Drexel, Good Sign Company, New York; Bill H. Ritchie, Jr., Seattle; Dieter Dietz, Dietz Offizin, Soyen, Germany; and those affiliated with former workshops: James D. McNair, Sewell Sillman Foundation; Mrs. Norman Ives; and Mrs. Arnold Hoffman.

Several individuals and organizations involved in the publication of individual prints graciously provided information: Philippe Alexandre, Terry Dintenfass Inc., New York; Martha Fleischman, Kennedy Galleries, New York; Alice Rudin; Judith Golden; Sidney Shiff, the Limited Editions Club, New York; Grant Spradling, Spradling-Ames, Key West, Florida; Regina Stewart and Marshall Sornik, Artists Equity, New York; and Wayne Coleman, the Amistad Research Center, New Orleans. Still others were helpful in providing specific information or directing us to other sources: Margaret Glower, Print Collection, New York Public Library; Trudy V. Hansen, Rutgers Archives for Printmaking and Studios, Jane Voorhees Zimmerli Art Museum, New Brunswick, New Jersey; Elizabeth Hahn, Christie, Manson and Woods, New York; David and Reba Williams; and Robert Blackburn, Printmaking Workshop, New York.

We appreciate the cooperation of the following clients, who willingly loaned their prints to be photographed for the catalogue: Sandford C. and Susan L. Barnes, Karen Binder and Steven Medwell, Charles and Janice Helming, Philip J. Mease, Charlene and Paris Qualles, and Jerald and Patricia Olson.

Thanks also to Spike Mafford, for photographing most of the images for the catalogue, and to John T. Hill, Dennis R. Whitehead, and Chris Eden, for granting permission to use their photographs; to the staff at Marquand Books, particularly Ed Marquand for the clarity of his design and Marie Weiler for her painstakingly thorough editing; and to Don Ellegood, at University of Washington Press, for patiently waiting while the information was assembled. I especially would like to thank Professor Patricia Hills, Boston University, for her overall dedication to Lawrence's work and her scholarly contribution to the catalogue.

I would also like to express my deep appreciation to two members of my staff: Patricia Scott for her support and advice and Peter Nesbett for doing all the research on this project with relentless tenacity. Both Jacob Lawrence and Gwen Knight endured many hours of questioning and many interruptions in their already hectic schedule. We are very grateful for their patience and kindness.

—Francine Seders

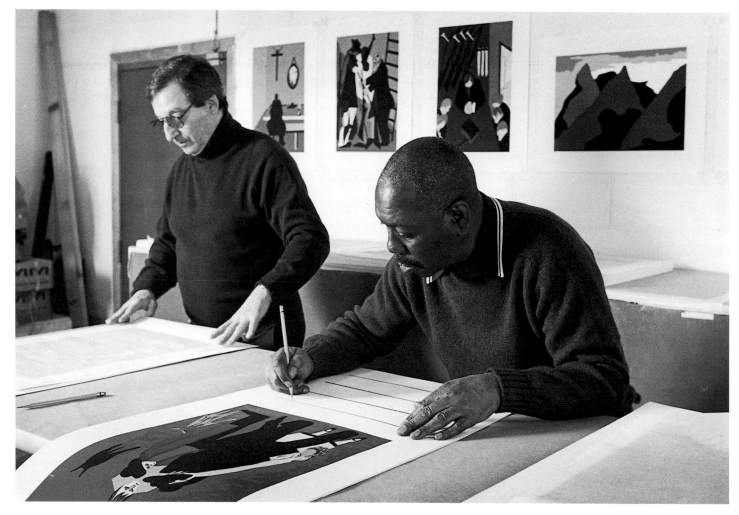

Jacob Lawrence signing The Legend of John Brown portfolio with Sewell Sillman, of Ives-Sillman, 1977.

Introduction
Jacob Lawrence: From Paintings to Prints

Peter Nesbett

When, at the age of forty-six, Jacob Lawrence executed his first print he was already an established painter. He had received early recognition in his twenties with solo exhibitions at the Phillips Collection, in Washington, D.C., and the Museum of Modern Art, in New York. In 1941, at the age of twenty-four he became the first African American to be represented in the Museum of Modern Art's permanent collection. By the 1950s, with the national spotlight on abstract expressionism, Lawrence's figurative narration received less acclaim, but by the end of the decade, media attention on civil rights struggles in the South renewed interest in Lawrence's more than two decades of painted revelations. In 1960 the Brooklyn Museum exhibited the first retrospective of his work, which toured to sixteen U.S. cities.

Lawrence's visibility in the early 1960s coincided with a burst of graphic activity in the United States. The newly attained international prominence of American art, an expanding private market, and technological advances prompted interest in printmaking, and in response to a demand for less expensive works by already-established American artists, print workshops and galleries encouraged painters to make prints. In 1963 Lawrence's dealer, Terry Dintenfass, invited him to create his first print,[1] *Two Rebels,* to accompany an exhibition of his work at her gallery.

The seven prints from Lawrence's first decade of printmaking (1963–72) reveal experimentation with a variety of media. Lawrence explored lithography, drypoint, etching, and silk screen, and his style evolved from a clear dependence on drawing to an increased emphasis on form and color.[2] In lithography he worked directly on the plate, both with lithocrayon and with brush and tusche, using the different techniques to serve the needs of his imagery. The energized crayon markings in *Two Rebels,* for instance, contrast sharply with the fluid, brushed lines of the more hopeful imagery in *Brotherhood for Peace,* 1967.[3] The only two intaglio prints in Lawrence's oeuvre display a similar exploration of medium and effect. Lawrence visualized *Market Place,* c. 1968, in the expressive, unrestrained lines of drypoint. In contrast, *Harriet Tubman (An Escape),* c. 1968, is rendered in the more subdued and delicate lines of etching, complementing the subject—a surreptitious escape by fugitive slaves through the night woods. By the end of this period of experimentation, Lawrence was incorporating in his prints the same rich color that pervades his paintings. *Workshop,* 1972, perhaps best illustrates this stylistic transition, combining the line and texture of drawing, as found in the early prints, with broad areas of flat, solid color prevalent in the prints through the end of the decade.

The distinction between the paintings and prints produced by Lawrence during his first ten years of printmaking is more pronounced than in those from any time since. The majority of the early images exist only in graphic form, and the correspondence to paintings is merely thematic. Lawrence's first print was, however, derived from a painting, and its inception established the magnetic correspondence that became evident over the next three decades. In form and content, the print (fig. 2) and the painting (fig. 1) are similar: both depict the arrest of civil rights protesters. Stylistically, however, each reflects the inherent characteristics of the medium in which it was made. In the print, the agitated marks of the lithographic crayon infuse the image with a dramatic intensity that is less prominent in the painting's soft contours, smooth textures, and colorful, integrated surface.

A period of increased graphic activity (1974–78) followed the earlier exploratory period, resulting in a body of prints that exhibit a high degree of consistency and maturity. Lawrence's 1974 retrospective at the Whitney Museum of American Art, in New York, prompted *Builders,* the first of these prints, and initiated a four-year collaboration with the silk-screen workshop of Ives-Sillman.[4] The Whitney retrospective also spurred a large number of commissions to benefit both for-profit and not-for-profit institutions. The artist's involvement in printmaking, which was initiated in part for commercial interests, was becoming increasingly philanthropic.

Lawrence's transition to silk screen resulted in a dramatic change in his working methods as a printmaker. The technical commitment required to produce multicolor screenprints was impractical for Lawrence, who, in his mid-fifties, was teaching and painting full-time. Rather than work on the individual screens, Lawrence created a painting as a model for the prints, retaining artistic control over the final product while relinquishing technical involvement.[5] The result was a

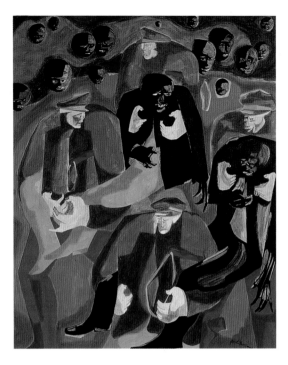

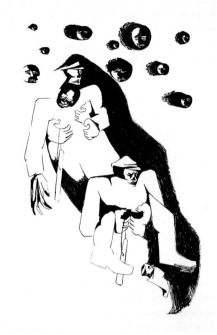

Fig. 1 (left). *The Rebels,* 1963, tempera on board, 23¼ × 19¼ in. (59.1 × 48.9 cm). Courtesy of the artist and Francine Seders Gallery.

Fig. 2 (right). *Two Rebels,* 1963. Lithograph, 30½ × 20⅛ in. (77.5 × 51.1 cm).

greater interdependence between his paintings and his prints, in process, though not in visual effect.

The screenprints executed by Lawrence in the 1970s exhibit a stylistic sensibility different from his paintings of this period.[6] Composed from a limited palette, Lawrence's designs for his prints are also more simplified, forfeiting both detailing and modeling for the characteristic strength of silk screen: the ability to produce clearly articulated, unmodulated areas of solid color.[7] Examination of the paintings created as models for *People in Other Rooms,* 1975, and *The Swearing In,* 1977, reveals Lawrence's sensitivity to the graphic medium. In both paintings, the artist applied color in a manner that conceals the texture of his brushstroke, imitating the machinelike consistency of color application intrinsic to the silk-screen process. Lawrence's three lithographs from this period (all dated 1977) display a similar aesthetic, most likely the result of the artist's involvement with silk screen.[8]

During the mid-1970s, while executing a number of individually commissioned prints, Lawrence also participated in a project to transfer to screenprints a series of paintings he had produced thirty-five years earlier. The twenty-two paintings from the John Brown series, 1941, in the collection of the Detroit Institute of Arts (DIA), had suffered severe paint loss, forcing the DIA to refuse a request to include the series in Lawrence's 1974 retrospective at the Whitney Museum.[9] In an effort to preserve and maintain access to the historically

significant series, the DIA contracted with Ives-Sillman to produce print portfolios, with Lawrence working as artistic consultant. The silk-screen process was chosen, in part, because of its ability to reproduce, without tonal variation, the flat, subtle colors of the original paintings.[10]

Though a fundamental reason for the silk-screen project was the preservation of Lawrence's original imagery, the John Brown prints nevertheless exhibit a high degree of stylistic autonomy (see figs. 3, 4). Since the fragile paintings could not be moved from the DIA and taken to the workshop in Connecticut, no effort was made to match the color, texture, or brushed nuances of the original paintings. None of Lawrence's criticism during the course of the project compared the original paintings to the prints, which were executed with a faithfulness to the inherent qualities of the new medium.[11]

The John Brown prints were technically the most complex Lawrence had yet produced. From eight to as many as twenty-five colors were used on each, requiring at least as many hand-cut stencils. In an effort to overcome the difficulty of registering numerous colors—a problem inherent in silk screen—Ives-Sillman layered the colors, rather than abutting them as had been done traditionally. The result is a series of images with rich, opaque surfaces that retain the tactile quality of a handmade surface so important to Lawrence's sense of craft.[12]

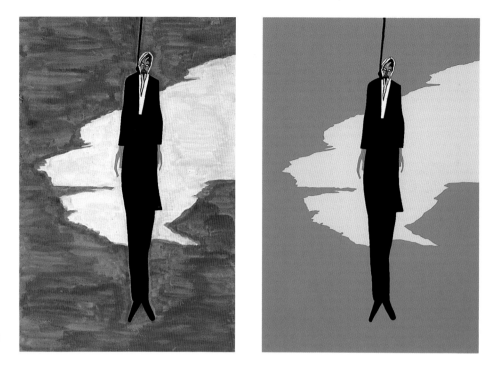

Fig. 3 (left). John Brown series, 1941.
No. 22: *John Brown was found "Guilty of treason and murder in the 1st degree" and was hanged in Charles Town, Virginia, on December 2, 1859.* Gouache on paper, 20 × 14¼ in. (51 × 36 cm), © Detroit Institute of Arts, gift of Mr. and Mrs. Milton Lowenthal.

Fig. 4 (right). The Legend of John Brown portfolio, 1977, No. 22. Screenprint; image: 20 × 14 in. (50.8 × 35.6 cm), paper: 25⅞ × 20 in. (65.7 × 50.8 cm).

Lawrence's printmaking in the most recent period of sustained graphic activity (1985–93) reflects a new relationship to his painting, willfully collapsing the previous decade's stylistic distinction between the two. The artist's increased desire to incorporate in prints the textures and brushed nuances present in the surfaces of his paintings is evident as early as the Hiroshima screenprints, of 1983. Lawrence's return to lithography in 1985 and the prints executed over the next eight years with Stone Press Editions underscore this new attitude. The use of lithography—by nature capable of achieving a greater variety of painterly effects—combined with an increased use of transparent printing inks has resulted in a layered, more watery surface (e.g., *Memorabilia,* 1990) that imitates the visual characteristics of Lawrence's paintings from this period. In addition, Lawrence has turned to a heightened use of texture and an expanded palette, visible in both *Man on Scaffold,* 1985, and *Grand Performance,* 1993.

Regardless of the presence of painterly effects in many of the recent prints, the treatment of form and composition reflects a graphic approach to printmaking, favoring dynamic, yet flat, compositions over a more illusionistic depiction of space.[13] In prints such as *Aspiration,* 1988, and *To the Defense,* 1989, where Lawrence has defined an architectural space, the flat, unmodeled forms and bright colors resist the pull of the horizon and float surprisingly close to the surface of the pic-

ture plane.[14] Otherwise, Lawrence's figures exist in a nearly two-dimensional world, their forms dissolving into a rich surface of pattern and movement. Two recent prints reflect a degree of abstraction not evident in any of Lawrence's previous prints. In *Revolt on the Amistad,* 1989, the figures are virtually indistinguishable from the dizzying patterns of rigging, limbs, and knives that depict the gory mutiny. And in *Celebration of Heritage,* 1992, Lawrence manifests the profound relationship of Native American peoples to their environment by negating any sense of depth or spatial differentiation.

Lawrence's post-1985 engagement with lithography runs concurrent with his continued use of silk screen. In 1986 the Amistad Research Center, in New Orleans, initiated a project to transfer to prints individual paintings from the Toussaint L'Ouverture series, of 1937–38. While this ongoing project is the second to translate paintings from Lawrence's early career to screenprints, it differs fundamentally from the Legend of John Brown portfolio, which remained faithful to the forms in the original paintings. With the Toussaint prints (eight of which have been completed), Lawrence has actively seized the opportunity to add new elements and alter form and color. As he explains, editing the original images has proved to be

like another creative step. The Toussaint paintings were done in the thirties. Fifty years later, when you are asked to transform an image into a print, a lot has happened in

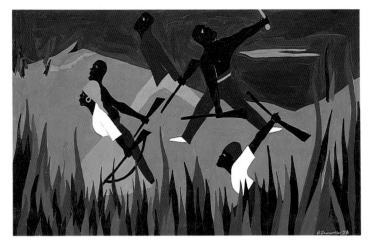

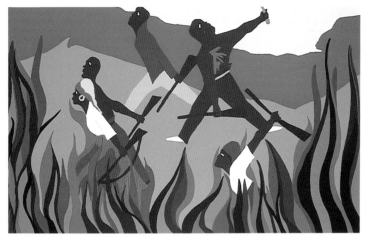

Fig. 5. Toussaint L'Ouverture series, 1937–38.
No. 38: *Napoleon's attempt to restore slavery in Haiti was unsuccessful. Desalines, Chief of the Blacks, defeated LeClerc. Black men, women, and children took up arms to preserve their freedom, November, 1802.*
Tempera on paper, 11 × 19 in. (27.9 × 48.2 cm). The Amistad Research Center, Aaron Douglas Collection.

Fig. 6. *To Preserve Their Freedom*, 1988. Screenprint; image: 18½ × 28¾ in. (47 × 73 cm), paper: 22 × 32⅛ in. (55.9 × 81.6 cm).

your thinking. . . . It would be very boring for me to try to copy what's already been done, so it becomes a new work: the same imagery, and the same story, but a new work.[15]

In *To Preserve Their Freedom*, 1988, Lawrence heightened the dramatic intensity of the image by imposing a wound on the central figure, adding bright red and yellow to the palette, and reconfiguring the foliage and sky (see figs. 5, 6). A similar sense of urgency permeates the changes manifested in *Contemplation*, 1993, upsetting the solemnity of the original painting (see figs. 7, 8).

A fund-raiser for the Amistad Research Center, the Toussaint project reflects the philanthropic nature of nearly all Lawrence's recent commissions. Sixteen of the eighteen commissions completed since the 1986 retrospective at Seattle Art Museum have provided economic support for nonprofit institutions, including among others the NAACP, the Schomburg Center for Research in Black Culture, the Amistad Research Center, and the American Indian Heritage Foundation. Lawrence's imagery throughout his oeuvre comments on the triumphs and struggles of the American people, and his prints, even more than his paintings, support both the mind and purse of these struggles.

The clarity and directness of Lawrence's imagery is intellectually accessible to a broad audience, and the artist's involvement with popular media has opened avenues of

communication that would not have been possible through painting alone. Since the early 1960s, Lawrence's printmaking has paralleled a number of projects in various media that, like his prints, have provided greater public exposure than his paintings: he has written and illustrated several children's books, executed numerous poster and illustration commissions, and completed eight murals. Aside from painting, however, which remains Lawrence's primary artistic activity, printmaking holds a dominant position in the artist's production of new imagery. A visual exploration of thirty years of Lawrence's prints is a thematic probe of his work as a whole, offering insight into the concerns of an artist who, at the age of seventy-six, has become one of the most revered American artists of this century.

Notes

In addition to those noted in the acknowledgments who contributed generously to the production of this catalogue, I would like to thank Andrea Moody, Alison Stamey, Tricia Eden, and Lorri Thompson for their support. I would also like to thank Robert Mintz and Beth Arman, who provided suggestions for improving the manuscript, and most of all, Shelly Bancroft for her encouragement, criticism, and good company.

1. Lawrence may have had some exposure to printmaking while at the Harlem Art Center in the 1930s, as photodocumentation of the period indicates. See Elizabeth Hutton Turner, ed., *Jacob Lawrence: The Migration Series* (Washington, D.C.: Phillips Collection, 1993), p. 36. Lawrence's involvement with the medium was minimal, however; he did not take classes in printmaking while at the Harlem Art Center, and no prints exist from that time. (Interview, Jacob Lawrence with the author, November 18, 1993.)

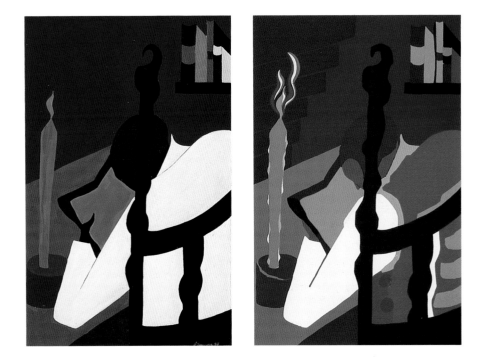

Fig. 7 (left). Toussaint L'Ouverture series, 1937–38. No. 27: *Returning to private life as the commander and chief of the army, he saw to it that the country was well taken care of, and Haiti returned to prosperity. This was a very important period. He saw that people took care of their lands and cattle, and that slavery was abolished.* Tempera on paper, 19 × 11 in. (48.2 × 27.9 cm). The Amistad Research Center, Aaron Douglas Collection.

Fig. 8 (right). *Contemplation*, 1993. Screenprint; image: 28⅜ × 18½ in. (72 × 47 cm), paper: 32 × 22 in. (81.2 × 55.9 cm).

2. In the 1950s Lawrence executed several drawings for events at Artists Equity that were reproduced as invitations. These one-color graphic projects might have informed Lawrence's early involvement with printmaking.

3. Lawrence's first lithographs, including *Two Rebels* and *Brotherhood for Peace*, were executed at George C. Miller & Son, the oldest fine-art lithographic workshop in the United States (est. 1917). George C. Miller & Son executed prints by many of the great American artists of the first half of this century, including George Bellows, Arthur Davies, and Thomas Hart Benton. The workshop has also executed prints by José Clemente Orozco and David Siqueiros, muralists whose work Lawrence admires, as well as Yasuo Kuniyoshi, with whom Lawrence exhibited at Edith Halpert's Downtown Gallery in the 1940s.

4. Ives-Sillman produced screenprints for Ad Reinhardt, Josef Albers, and others. Sewell Sillman had been a student of Albers at Black Mountain College, in North Carolina, and at Yale. In 1966, Ives-Sillman published a voluminous portfolio entitled *Interaction of Color,* which recorded the writing and color studies of Albers's teachings at Yale. Lawrence met Albers in 1946 while teaching summer school at Black Mountain College and was profoundly influenced by the former Bauhaus master. See Ellen Harkins Wheat, *Jacob Lawrence: American Painter* (Seattle: Seattle Art Museum and University of Washington Press, 1986), p. 73.

5. The majority of Lawrence's prints since 1974 have been executed in this manner, with the exception of *Carpenters, Tools,* and *Windows* (all 1977), which were drawn by Lawrence directly on the plate. *Builders Three* (1991) was drawn and color separated by Lawrence on mylar.

6. Paintings executed independently of print commissions retain a greater degree of detail, a frequent experimentation with texture, and an expanded palette. However, as Ellen Harkins Wheat points out in her monograph on Lawrence, the paintings from the 1970s also generally reflect the influence of Lawrence's greater involvement with graphics. See Wheat, *American Painter*, p. 144.

7. The inherent qualities of the medium were embraced by minimalist and post-minimalist artists in the 1960s and 1970s, as well as by artists of the 1930s, such as William H. Johnson, whose style and content are more closely aligned to Lawrence's imagery.

8. The paintings Lawrence executed for poster commissions exhibit a similar treatment of form, use of color, and compositional style, particularly evident in *Brooklyn Stoop* (1967) and the study for *Bumbershoot '76* (1976). Several of Lawrence's prints emerged from poster commissions (e.g., *The Builders*, 1974, and *Memorabilia*, 1990), but in general, Lawrence's approach to these images accords with his approach to printmaking during each period of activity.

9. Only five of the paintings were allowed to travel from the DIA to the Whitney exhibition. For the traveling retrospective organized by Seattle Art Museum in 1986, only three of the paintings were exhibited in Seattle, and none was permitted to travel with the exhibition.

10. *The Legend of John Brown* (Detroit: Detroit Institute of Arts, 1978), p. 11.

11. Ibid.

12. The screenprints printed by Lou Stovall at Workshop, Inc., exhibit a similarly opaque surface. The ink used in silk screen, when printed in multiple layers, appears to sit on the surface of the paper. Lithographic inks, on the other hand, have the visual effect of being absorbed more completely into the surface of the paper. This became an important and exploited distinction in the 1980s, when Lawrence was printing in both lithography and silk screen.

13. The dialectic between surface and depth permeates all of Lawrence's aesthetic production. His paintings from the late 1950s and early 1960s are patterned, flat, and decorative. His works in the late 1960s and 1970s, however, exhibit a return to an interest in volumetric, illusionistic space. Though Lawrence's paintings since that time show an alternation between attention to surface and attention to depth, in his graphic work he almost exclusively indulges his interest in flatness.

14. Lawrence created the painting for *Aspiration* (1988) with a sensitivity toward creating a successful graphic image. Upon completion of the print edition, Lawrence returned to the painting and added modeling and shadows.

15. Interview, Jacob Lawrence with the author, June 30, 1993.

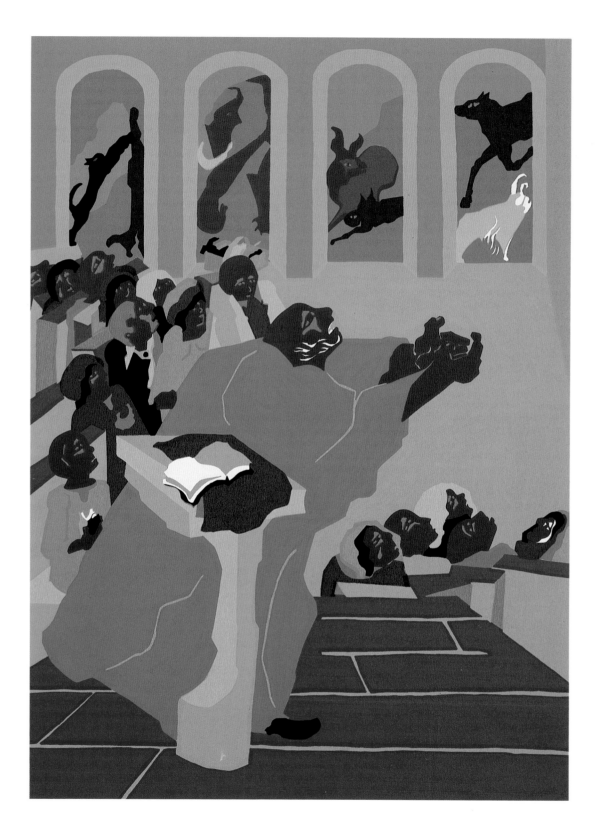

The Prints of Jacob Lawrence: Chronicles of Struggles and Hopes

Patricia Hills

Jacob Lawrence began to produce prints in earnest in the early 1970s, long after he had matured as an artist and developed a signature style: a reductive, figurative modernism uniquely wedded to socially concerned subject matter. His style, then and now, is characterized by tight interlocking patterns of simplified shapes with a limited palette of flat, pure color; his subjects come from the African American community: its history, storytelling, and contemporary life. Lawrence's art consistently focuses on working-class people living in communities and on their struggles to confront oppression, to overcome daily adversities, to educate themselves, and to achieve. Although pictures by Lawrence might be specific in their topical references or regional in their genre types, his work often points to a larger ethical or historical message about humanity as a whole. This seems most deliberate in his limited edition prints and mass-produced posters, almost always done as commissions from educational institutions or non-profit organizations.[1]

It was in Harlem during the 1930s that Lawrence developed his artistic abilities to infer general significance from specific scenes, to blend the present with the past, and to show joy emerging from hardship. In spite of the economic stresses of the depression, his Harlem community of family and relatives, ministers and church ladies, school teachers, shopkeepers, and street-corner orators nurtured his bonds to African American traditions. The art community there, with its workshops, the Harlem Artists Guild, and the Harlem Art Center, expanded his ideas about art, its possibilities, its responsibilities. Fellow students, such as Romare Bearden, Ronald Joseph, Bob Blackburn, and Gwendolyn Knight stimulated him, and his older mentors—painters Charles Alston and Henry Bannarn, sculptor Augusta Savage, and writers Claude McKay and Alain Locke—encouraged him. For the catalogue of Lawrence's first solo exhibition, held at the Harlem YMCA in 1938, Alston noted Lawrence's unusual empathy with his Harlem neighbors:

> He is particularly sensitive to the life about him: the joy, the suffering, the weakness, the strength of the people he sees every day. . . . Still a very young painter, Lawrence symbolizes more than anyone I know, the vitality, the

seriousness and promise of a new and socially conscious generation of Negro artists.[2]

Throughout his career, Lawrence created compositions showing people either acting as members of a group or leading as heroes—such as Toussaint L'Ouverture, Frederick Douglass, Harriet Tubman, and John Brown—in the historical narrative of African Americans. Rarely do Lawrence's people behave as isolated individuals pursuing their personal dreams or fighting their personal demons.[3] To the artist, the community mattered most, and he responded to the stories of its members by becoming their pictorial griot—their storyteller spinning visual images.

To communicate his message about the community and to the community, Lawrence needed to ground his art in an effective style that would engage his audience. Again, he came to his credo about artmaking early. In a statement made in the mid-1940s, Lawrence said: "For me a painting should have three things: universality, clarity and strength. Universality so that it may be understood by all men. Clarity and strength so that it may be aesthetically good."[4] The modernist, expressive cubism he had arrived at in the 1930s suited these requirements.

From the 1960s to the present, Lawrence's prints, like his paintings, fall into two major groups: genre images of a community united in work, study, and play that border on the allegorical; and protest images of a community united in struggle. The protest images rise to the level of epic when they depict not just individuals victimized by political and economic oppression and racism but dramatize the collective will to freedom. In the last thirty years of making prints, Lawrence has moved back and forth between these genre scenes of a harmonious community and the scenes of struggle. These dialectical swings suggest the man himself today, for Lawrence offers the public a countenance of peace and wisdom behind which emerge passionate feelings for the humanity and dignity of ordinary people.

Lawrence's earliest lithographs—*Two Rebels*, 1963, and *Brotherhood for Peace*, 1967 (both with little or no color)—exemplify the shifting themes in his art. Lawrence designed *Two Rebels* at a time when the civil rights movement figured

prominently in the news. The movement reached a high point when African Americans and their white comrades—some students from the South, others from the North—confronted local police during their efforts to integrate segregated restaurants, organize voter registration drives, and combat Jim Crow laws in general. Violence erupted, however, and the "rebels" were arrested, imprisoned, and even brutally murdered. Such events deeply affected Lawrence, and in 1963 he made some of his strongest images of social protest, many of which were exhibited at Terry Dintenfass Gallery.

As a contrast to the protest pictures, during the 1960s Lawrence continued to mine scenes of everyday life for subject matter resulting in genre images that at times attained the status of allegory. In *Brotherhood for Peace*, a commission from the Waltham Watch Company in 1967, four people, of black, brown, yellow, and light pink skin tones gather around a circular table and embrace one another's shoulders. Like the numerals of a clock—an apt composition for a watch company—no figure dominates. All are equal in this image of unity and harmony that speaks for an integrated society.[5]

Lawrence's commission in 1971 to design the screenprint *Olympic Games* marks his heightened commitment to print-making activity. For this occasion the artist worked in a larger format and broadened his palette to include the three primary colors plus green, brown, and black. The five runners shown are not individual runners, rather each is represented as a member of his relay team, a fact made explicit by the baton each carries. To Lawrence, the passing of the baton is a metaphor for culture—the transmission of skills, ideas, and hopes. When asked by curator Patterson Sims, at a public forum held in 1993, to evaluate the younger generation of African American artists, Lawrence replied, "we pass the baton from one generation to the next." This transference of traditions to younger generations, he explained to Sims, gives him "a very positive feeling"[6]—a feeling that supersedes what he might think about any individual younger artist. Thus, not only does each runner in *Olympic Games* belong to a group that gives him identity, but the athlete, like the artist, serves as a necessary link in a progression of actions connecting the past with the future.

During the 1970s Lawrence turned with increasing frequency to the subject of carpenters, in their workshops and on building sites. Several prints came out of this new preoccupation, including *Workshop*, 1972, *The Builders*, 1974, *Builders No. 3*, 1974, *Carpenters*, 1977, *Tools*, 1977, and later, *Man on Scaffold*, 1985, and *Builders Three*, 1991. As a group these images convey several messages: the harmonious racial integration of workers, the positive goals of building strong communities, and the beauty of work itself. In Lawrence's carpenter pictures, the work ethic commands respect—not just

because work puts bread on the table but because labor brings people of all races together, because work can be exhilarating, and because tools are beautiful in themselves. Lawrence, a collector of such carpentry tools as old planes, sees "aesthetic beauty in how the tool emerges from the hand and how the hand itself is a beautiful tool," and he marvels that the same carpentry tools seen in Italian Renaissance paintings are still in use today.[7]

In these carpenter images Lawrence achieves his goal of projecting universality, clarity, and strength: universality, because his community of work incorporates not only all races but all eras, and clarity and strength as a result of the artist's modernist manipulations of form and color. Besides people, a profusion of tools and materials occupies the work spaces—lengths of lumber, saws, hammers, drills, clamps, planes, levels, and rulers. Their precise lines and horizontal stability, activated by crossing diagonals and shifts into deep perspective, set up staccato rhythms filled with lively color.

In contrast to the theme of manual labor depicted in his carpenter series, the library pictures, such as *The Library*, 1978, and *Schomburg Library*, 1987, give pictorial form to intellectual labor, and thus also highlight a debate that energized educational circles within the African American community, a debate that Lawrence would have been aware of since his youth. The education of black youth was, and is, inseparable from the goal of the cultural, social, and economic improvement of African American communities. The educator Booker T. Washington, who founded Tuskegee Institute in Alabama in 1881, believed that blacks needed to train themselves in such basic skills as carpentry in order to get ahead; political rights and integration were issues of less importance than were work and discipline as means to economic opportunity. Social scientist, editor, and activist W. E. B. DuBois, on the other hand, felt that blacks ought to be entitled to the same education in the liberal arts as whites, and he viewed voting rights and integration as crucial goals. DuBois envisioned a "talented tenth" of the African American population as a cadre leading black advancement.

Thus, while Lawrence returns repeatedly to the subject of carpenters, whose skills do indeed make for a more comfortable life for the individual while giving pride to the community, he also endorses the outlook of DuBois. Both men believed that the acquisition of an intellectual and historical understanding of human experience would lead to fundamental changes in the consciousness of people. Lawrence, like DuBois, had honed his mental skills in the libraries he frequented as a youth. Especially in the Schomburg branch of the New York Public Library, Lawrence amplified his knowledge of American history and African American traditions. There, too, was a place where the community could

come together in quiet, mutual support. In the library pictures, Lawrence translated these concepts into visual metaphors. Hence, while the orderly stacks of books represent the weight of tradition, the diagonal movements of the figures symbolize the dynamic processes of acquiring knowledge. In Lawrence's vision of African American advancement, if community members are not in the library, they are at home reading, as in the lithograph *Aspiration,* 1988. And, like DuBois in his early years, Lawrence's African Americans have faith in the democratic process as they go to the polls in *The 1920's . . . The Migrants Arrive and Cast Their Ballots,* of 1974, or witness the president's inauguration in *The Swearing In,* of 1977.

With *Memorabilia,* 1990, and *Celebration of Heritage,* 1992, Lawrence reminds us that cultural traditions rest on more than book knowledge. Originally commissioned in 1988 by Vassar College for the twentieth anniversary of its Africana Studies program and ultimately produced as a poster for the college, *Memorabilia* depicts a shop scene with five people working among the mementos and trophies of our American heritage: a small statuette of Harriet Tubman graces a top shelf; other statuettes in the room include three black Civil War soldiers, a jazz trio, a preacher and singers, and a robed graduate, symbolizing academic achievement. With *Celebration of Heritage,* 1992, printed for the American Indian Heritage Foundation exhibition held at the 1992 World's Fair Exposition in Spain, Lawrence reminds the viewer that it is the Native American community that is most cognizant of the contribution of the earth to human welfare.

During the years that Lawrence designed scenes of the community acquiring knowledge through manual skills and library work, he also created pictures dramatizing the struggle against oppression. In 1975, at a time when the nation had begun to celebrate the bicentennial of the Declaration of Independence, many artists gave thought to the oppressions yet remaining and the injustices still to be corrected. Lawrence's *Confrontation at the Bridge* represents a community of African Americans standing on a narrow footbridge, facing a snarling dog that blocks their movement forward. Such incidents were routinely experienced by civil rights workers, and Lawrence focused here on the 1965 march from Selma to Montgomery, Alabama, when civil rights supporters were stopped at the Edmund Pettus Bridge. By their sheer numbers they were able to push on, as do all people with sufficient determination.

In 1977 Lawrence turned again to the theme of organized resistance when he translated the twenty-two gouache panels of the 1941 John Brown series into screenprints. A deeply religious abolitionist, Brown came to believe that the only way African Americans could free themselves from slavery was by armed revolt. His courageous raid with a small band of rebels on the arsenal at Harper's Ferry, West Virginia, resulted in his arrest and execution. No matter that Brown was a white man; he had been a hero in the cause of freedom for African Americans and was part of Lawrence's community.

Lawrence has also returned to the life of Haitian revolutionary Toussaint L'Ouverture, and since 1986 has produced eight screenprints. He did his first series of forty-one gouache panels on the life of Toussaint during 1937–38, while still a student at the American Artists' School, and these paintings won him national recognition when Howard University professor Alain Locke arranged for them to be included in the Exhibition of Contemporary Negro Art, held at the Baltimore Museum of Art in 1939. It was the revolutionary content of the eighteenth-century Haitian narrative that appealed to Lawrence, who explained in 1940:

> I didn't do it just as a historical thing, but because I believe these things tie up with the Negro today. We don't have a physical slavery, but an economic slavery. If these people, who were so much worse off than the people today, could conquer their slavery, we certainly can do the same thing. They had to liberate themselves without any education.[8]

That Lawrence should return to the narrative of political liberation in Haiti comes as no surprise, since the impoverished country continues to figure in the news as the site of ongoing discontent and fighting against authoritarianism. Lawrence's screenprints, with their elegant beauty, remind his audience of the country's tradition of heroic rebellion.

Other prints on the theme of struggle against oppression include his *Revolt on the Amistad,* 1989, depicting the rebellion on board the slave ship that brought Cinque and other kidnapped West Africans to America in 1839. Unlike the static figures of *Confrontation at the Bridge,* the movement of the ribbonlike shapes (flailing knives and rigging ropes) in *Revolt on the Amistad* suggests not only a shipboard rebellion but also the streamers of a celebration. In fact, the Supreme Court finally judged the West Africans not guilty of the murder of the Amistad captain and cook, and they were allowed to return to Africa free men. Hence, although Lawrence's scene represents a rebellion, it nevertheless hints at the eventual victory.

Both the Hiroshima portfolio, 1983, and Eight Studies for the Book of Genesis, 1990, are epics that move away from African American narratives and comment on human history as a whole. Both series encourage us to look to the future, while pondering the past. The Hiroshima series recalls the destructive power of science when used in wars against humanity; we pity the victims and fear such an apocalyptic fate for ourselves. Genesis, on the other hand, soothes us with the balm of shared memories and reminds us of the empowering experiences of communities that share beliefs.

When Lawrence chose John Hersey's *Hiroshima* to fulfill a commission from the Limited Editions Club, he embraced an opportunity to transcend racial and nationalist consciousness. Hersey's chronicle, first published in the *New Yorker* on August 31, 1946, follows the lives of six people from the hours before the atomic bomb exploded at 8:15 A.M. on August 6, 1945, through the following hours, then days, when the enormity of the situation was finally grasped by the world. Many moments of heroism emerged in Hersey's relentlessly piteous account.

Lawrence's panels evoke a combination of the horror graphically detailed by Hersey along with the quiet courage of the community in the moments of shared trauma. The faces are skulls with red, pink, or brown eye sockets—evocations of the "faces . . . almost blotted out by flash burns" described by Hersey. *Farmers* depicts the moment when the noiseless flash occurs. *Market* and *Street Scene* suggest the subsequent moments of chaos when large pieces of building debris fly through the air around the heads of people. *People in the Park* represents the aftermath, a time of great stoicism when, as Hersey recounts, "no one wept, much less screamed in pain." For this series of prints Lawrence includes colors not usually found in his other works: bleached out pinks, yellows, and blues. The shapes have savagely ripped edges—appropriate to the enormity of the cataclysm, the irrational targeting of victims, and the universality of suffering.

In 1989 Lawrence accepted another commission from the Limited Editions Club for illustrations to accompany the King James version of the book of Genesis. Lawrence chose scenes not from the Bible, but rather, scenes from his childhood memories of his community that recalled the preacher of Harlem's Abyssinian Baptist Church delivering impassioned sermons to his congregation. In the eight scenes, the preacher shifts from side to side and changes vestments from blue, to yellow, green, black, and red, while the congregation remains spellbound. In the background, under four arches, the preacher has conjured images of the seven days of creation—from the void, to the formation of the earth and waters, flora and fauna, and finally man and woman.

Lawrence's most recent print, *Grand Performance*, 1993, sums up his view of Harlem as a cultural community. Both a limited edition print and a poster for the NAACP's Stay in School campaign, *Grand Performance* portrays another of Lawrence's youthful experiences, that of going to the Apollo theater as a young man. At the Apollo both the performers and the audience impressed him with their emotional engagement with each other as they laughed "with tears streaming down their cheeks."[9] In Lawrence's image the proscenium arch has disappeared and the wings have moved back to allow a medley of singers, dancers, musicians, and comedians to perform before an appreciative audience, which proffers roses to the performers. The scene portrayed in *Grand Performance* is also a metaphor for Lawrence's own career vis-à-vis his community. Without an audience—a supportive community—Lawrence feels he could never have made his art into the grand performance, the ambitious oeuvre, that it is.[10]

Lawrence has kept the faith. In Charles Alston's words of over fifty years ago, and quoted above, Lawrence is still "particularly sensitive to the life about him: the joy, the suffering, the weakness, the strength of the people he sees every day." His images, whether seen in museums, disseminated through limited edition prints and posters, or reproduced in books, remind us that struggle, unity, and hope are the best weapons to strengthen the concept of community and merge it with the aspirations of all of humanity.

Notes

In writing this essay, I have benefited from the scholarship that informed the catalogue raisonné of the prints, and I want to thank Peter Nesbett for making it available to me. I also want to thank Kevin Whitfield for his careful reading of my text.

1. Since Lawrence was already a well-established artist when he began to receive commissions for print editions, he had considerable latitude in his selection of subjects. Often the composition was drawn from a previous image and met with the complete approval of the commissioning agency. (Lawrence confirmed this with me on January 11, 1994.)

2. Catalogue included in Lawrence scrapbook (early years), George Arents Research Library, Syracuse University.

3. There are exceptions, however, particularly during the early 1950s, when Lawrence's imagery became extremely introverted.

4. Undated clipping affixed to Lawrence scrapbook (early years), George Arents Library, Syracuse University. "ALA News" is inscribed in ink in the margin.

5. In that same year, Lawrence designed a poster for the Goddard Art Center in New York, entitled *Brooklyn Stoop*, which shows a scene of racially integrated children at play. See Ellen Harkins Wheat, *Jacob Lawrence: American Painter* (Seattle: Seattle Art Museum and University of Washington Press, 1986), pl. 73.

6. Interview, Jacob Lawrence with Patterson Sims, College Art Association conference, Seattle, February 4, 1993.

7. Interview, Jacob Lawrence with the author, January 11, 1994.

8. Statement issued by the Harmon Foundation, Inc., dated November 12, 1940, Downtown Gallery Papers, Roll ND5, Archives of American Art, Smithsonian Institution. Eight works in the Toussaint series were reproduced in Alain Locke's *The Negro in Art: A Pictorial Record of the Negro Artist and of the Negro Theme in Art* (Washington, D.C.: Associates in Negro Folk Education, 1940).

9. I am grateful to Peter Nesbett for informing me of Lawrence's description of his experience as it relates to this print, from a lecture at Henry Art Gallery, University of Washington, Seattle, August 12, 1993. In 1951–52 Lawrence painted the Theater series; *Vaudeville* (collection, Hirshhorn Museum and Sculpture Garden) depicts a figure with tears streaming down his face.

10. Lawrence's acknowledgment that his artistic roots lie within the community is the major theme of his talks before public audiences. For the role of the Harlem community in Lawrence's art, see Patricia Hills, "Jacob Lawrence as Pictorial Griot: The *Harriet Tubman* Series," *American Art* 7 (Winter 1993):40–59; and essays by Henry Louis Gates, Jr., et al. in Elizabeth Hutton Turner, ed., *Jacob Lawrence: The Migration Series* (Washington, D.C.: Phillips Collection, 1993).

Catalogue Raisonné of Prints

Catalogue Abbreviations and Comments

This catalogue documents Jacob Lawrence's production of published limited edition prints through 1993. The prints are listed chronologically by date of creation/publication, with the exception of the eight prints completed to date from the Toussaint L'Ouverture series, which are grouped chronologically at the end of the catalogue.

All information herein is as accurate as possible given the difficulties of finding information on the early prints. Prints existing outside the standard commercial edition are noted when known, as are variations to an edition's standard inscription format.

All prints are on white paper and are inscribed by the artist; however, because illustrations are cropped to the image, inscriptions may not be visible. All printer's chop marks are embossed (blindstamps).

All dimensions are expressed in inches followed by centimeters; height precedes width.

Italicized texts in quotations are statements by the artist.

Terminology

The term *lithograph* denotes a work printed on a direct-process flat-bed lithographic press. *Offset lithograph* denotes a work printed on an offset rotary press. For both plates and screens, a distinction is made in the cataloguing between direct processes and photo-transfer processes. The term *wove paper* denotes paper that does not readily show wire marks from the papermaking mold.

AP EA	artist's proof *épreuve d'artiste*	A print created for the possession of the artist outside the numbered edition but equal to it in quality
PP	printer's proof	A print created for the possession of the printer outside the numbered edition but equal to it in quality
HC	*hors commerce*	Literally, "not for sale"; a print generally for a collaborator or for exhibition purposes
AR	archival proof	A print created for archival or exhibition purposes outside the numbered edition but equal to it in quality
BAT	*bon à tirer*	Literally, "good to pull"; the first impression in the proofing period that meets the standards for the edition and against which all subsequent proofs are judged
WP	working proof	A print retained from the proofing period to document image changes
CP	color proof	A print retained from the proofing period to document color changes
TP	trial proof	A print retained from the proofing period
CL	cancellation proof	An impression demonstrating the destruction of a plate or screen

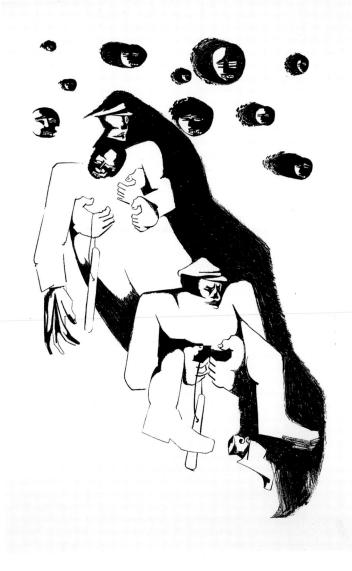

63-1

Two Rebels

1963

Lithograph on Rives paper
From a plate hand drawn by the artist
Edition of 50
Plate destroyed
Image: 30½ × 20⅛ (77.5 × 51.1)
Paper: 30½ × 20⅛ (77.5 × 51.1)

Signed and dated bottom center *Jacob Lawrence 1963*, titled and inscribed
bottom left in pencil below the image *Two Rebels Ed.50*; no printer's chop
mark.

Published by Terry Dintenfass Gallery, New York; printed by George C.
Miller & Son, New York (Burr Miller, master printer).

Also printed as an offset poster for the artist's exhibition at Terry
Dintenfass Gallery, March 25–April 20, 1963.

Throughout the 1960s, Lawrence continually worked with images pertain-
ing to the struggle for civil rights in the United States. *Two Rebels* is the
only print executed during that period that relates to that body of work.
The image derives from the painting *The Rebels* (1963), which depicts two
men being carried by four policemen.

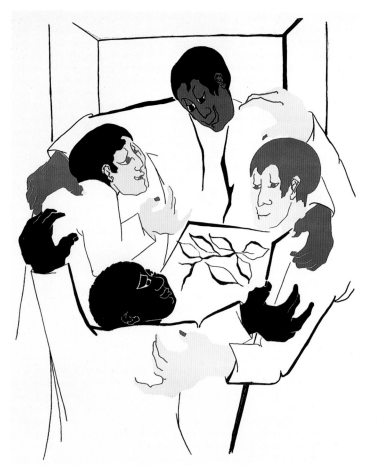

67-1

Brotherhood for Peace
1967

Lithograph on Rives Heavyweight paper
From plates hand drawn by the artist
Edition of 300
Plates destroyed
Image: 21½ × 17 (54.6 × 43.2)
Paper: 24 × 20 (61 × 50.8)

Signed and dated bottom right *Jacob Lawrence 1967*, titled bottom center, numbered bottom left in pencil below the image; no printer's chop mark.

Published by the Waltham Watch Company, Waltham, Massachusetts; printed by George C. Miller & Son, New York (Burr Miller, master printer).

"I am dealing with struggle throughout my [work]. Sometimes that struggle is apparent, sometimes it is not apparent. I think struggle is a beautiful thing. I think it is what made our country what it is, starting with the revolution. The American people in general have always gone through this. Of course the black people have continued this struggle also. I would like to think of this symbol [of struggle in my work] as being not just a black symbol, but a symbol of our—man's—capacity to endure and to triumph."

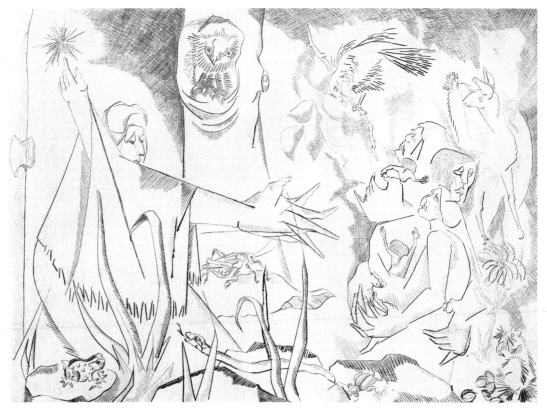

68-1

Harriet Tubman (An Escape)

c. 1968

Etching and drypoint on wove paper
From a plate hand drawn by the artist
Image: 9¾ × 13½ (24.8 × 34.3)
Paper: 19⅞ × 22¾ (50.5 × 57.7)

No signed and numbered prints are known to exist. Title is descriptive and not necessarily what appeared on prints from the edition. Edition is thought to have been small (twenty–thirty).

Published as a fund-raiser for Artists Equity, New York.

Lawrence first dealt with the theme of Harriet Tubman in a series of thirty-one paintings executed in 1939–40. In 1967 he used the theme again, executing twenty-one paintings (seventeen of which were used) for a children's book, *Harriet and the Promised Land*, which was published by Windmill Books/Simon & Schuster in 1968. This print is similar to the tenth image in the book and was probably executed shortly after completion of the paintings. The image depicts Harriet Tubman leading fugitive slaves to the safety of the North Star. Lawrence's caption for the image in the book reads: "A snake said, 'Hiss!' / An owl said, 'Whoo!' / Harriet said, 'We are coming through!' / A runaway slave / with a price on her head, / 'I'll be free,' said Harriet, / 'Or I'll be dead!'" The image is reversed from that of the painting and the animals, insects, and forest are all depicted differently than in the painting.

Harriet Tubman was born a slave in eastern Maryland. In about 1849 Tubman escaped to freedom in Pennsylvania guided at night by the North Star. During the following decade, she returned to the South nineteen times, guiding more than three hundred slaves through the Underground Railroad to freedom in the North.

68-2

Market Place

c. 1968

Drypoint on wove paper
From a plate hand drawn by the artist
Image: 10 × 13½ (25.4 × 34.3)
Paper: 19⅞ × 22⅞ (50.5 × 58)

No signed and numbered prints are known to exist. Title is descriptive and not necessarily what appeared on prints from the edition. Edition is thought to have been small (twenty–thirty).

Published as a fund-raiser for Artists Equity, New York.

Lawrence executed at least two other images of markets in the mid-1960s: *Meat Market* (1964), from the Nigerian series, and *Market Place* (1966); both were based on his travels to Africa. An earlier painting, *Fruits and Vegetables* (1959), is also thematically related.

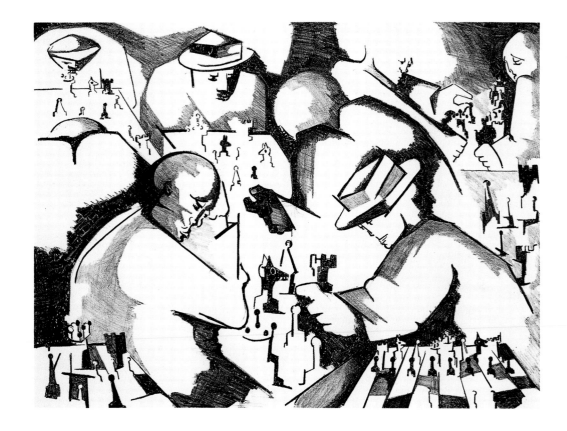

70-1

Chess Players

1970

Lithograph on German Copperplate paper
From a stone plate hand drawn by the artist
Edition of 30
Plate destroyed
Image: 13⅞ × 18⅞ (35.2 × 48)
Paper: 20½ × 24¾ (52.1 × 62.9)

Signed and dated bottom right *Jacob Lawrence 1970,* titled bottom center, numbered bottom left in pencil below the image; printer's chop mark bottom right.

Published by Jacob Lawrence; printed by faculty and students of the School of Art, University of Washington, Seattle (Professor Bill Ritchie and Christy Wyekoff).

Executed while Lawrence was a visiting artist at the University of Washington, April–June 1970. This print was part of an effort by Professor Ritchie and his students to encourage collaborative projects between members of the printmaking department and other studio faculty.

Note: 13/30 misdated 1930.

This theme is present earlier in Lawrence's work, as evidenced by the paintings *Chess on Broadway* (1951) and *Street Shadows* (1959).

In the 1940s and 1950s Lawrence frequented chess parlors in New York City on 42nd Street and at the Harlem YMCA. He has maintained his interest in chess throughout the years, following tournaments in the newspapers and playing often with his wife, Gwendolyn Knight, in the evenings.

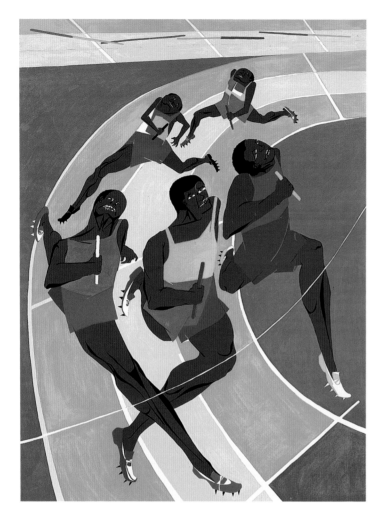

71-1

Olympic Games
1971

Screenprint on Schoellers Parole paper
From hand color-separated photo stencils
Edition of 200
Image: 34⅜ × 25⅜ (87.2 × 64.5)
Paper: 42½ × 27½ (108 × 69.9)

Signed and dated bottom right *Jacob Lawrence 71*, numbered bottom right in pencil below the image; no printer's chop mark.

Published by Bruckmann Verlag + Druck, Munich (Edition Olympia 1972); printed by Dietz Offizin, Lengmoos, Germany; distributed in the United States, Canada, and Japan by Kennedy Graphics, New York.

Also printed in an edition of four thousand, signed in the screen, on archival paper, and in an unlimited-edition offset poster on archival paper. All prints, including the edition of two hundred, are printed on paper bearing *Olympische Spiele München 1972*, the Olympic rings, and the Munich emblem below the image.

This print was one of twenty-eight by individual artists published by Edition Olympia on the occasion of the 1972 Munich Olympic Games.

Lawrence created this image to commemorate the involvement of black athletes in the Olympic games, track being an event in which black athletes had traditionally excelled. While living in New York, Lawrence and his wife annually attended track-and-field events at Madison Square Garden, and the running contests were personal favorites.

72-1

Workshop*

1972

Lithograph on Rives BFK paper
From plates hand drawn by the artist
Edition of 100 with 10 AP
Plates destroyed
Image: 22½ × 17½ (57.1 × 44.4)
Paper: 27 × 22 (68.5 × 55.9)

Signed and dated bottom right *Jacob Lawrence 1972*, titled bottom center, numbered bottom left in pencil below the image; no printer's chop mark.

Published by Abrams Original Editions, a division of Harry N. Abrams, New York; printed by George C. Miller & Son, New York (Burr Miller, master printer).

*Variously titled *Workshop, The Workshop, Builders #1.*

Workshop was commissioned by Abrams Original Editions to fund a book project on Lawrence's work. Carol Greene began work on the manuscript, Charles Alan (Lawrence's dealer in the 1950s) took over the project and brought the manuscript to near completion, but the book was never published.

Beginning in the late 1960s Lawrence began to regularly incorporate in his paintings images of builders, a theme he had previously used sporadically (*Cabinetmakers,* 1946; *The Builders,* 1947; *Cabinetmaker,* 1957). *Workshop* is the first of Lawrence's prints to address this theme.

"I was about fifteen or sixteen and I was exposed to cabinetmakers—I wasn't a cabinetmaker myself—and I remember them working with tools. I never thought I'd be using this content in my painting, but evidently it was having a great meaning for me. So now I collect tools. I am not a collector, but I collect them. I can't drive a straight nail but I use them in my paintings as a painter would a still-life."

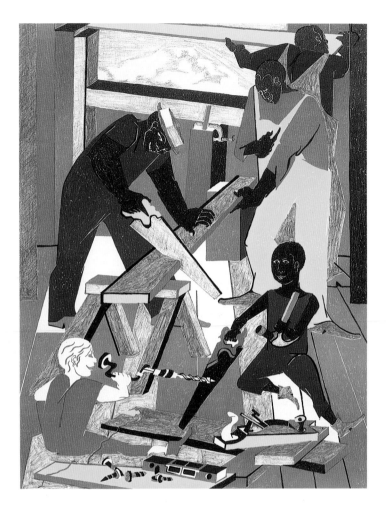

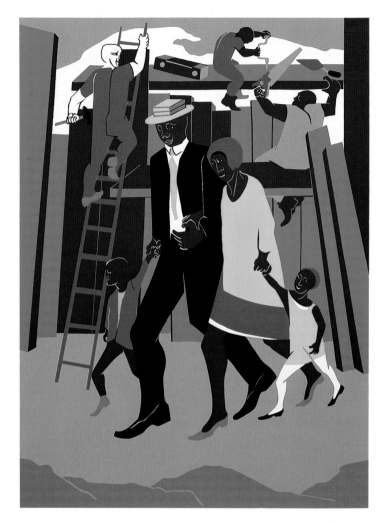

74-1

The Builders*
1974

Screenprint on wove paper
From hand-cut film stencils
Edition of 300 with 20 AP
Screens destroyed
Image: 30 × 22⅛ (76.2 × 56.2)
Paper: 34 × 25¾ (86.3 × 65.4)

Signed and dated bottom right *Jacob Lawrence 1974*, titled bottom center, numbered bottom left in pencil below the image; printer's chop mark bottom right.

Published by IBM Corporation, New York; printed by Ives-Sillman, New Haven, Connecticut.

*Variously titled *The Builders*, *The Family*.

Also printed as a poster.

For the poster of his 1974 retrospective at the Whitney Museum of American Art, New York, Lawrence was given the option of either using an existing painting or creating a new work. He chose to create a new painting, which was reproduced on the cover of the exhibition catalogue and published as an edition of prints that was distributed jointly by the Whitney and Terry Dintenfass Gallery.

"The Builders [theme] came from my own observations of the human condition. If you look at a work closely, you see that it incorporates things other than the builders, like a street scene, or a family."

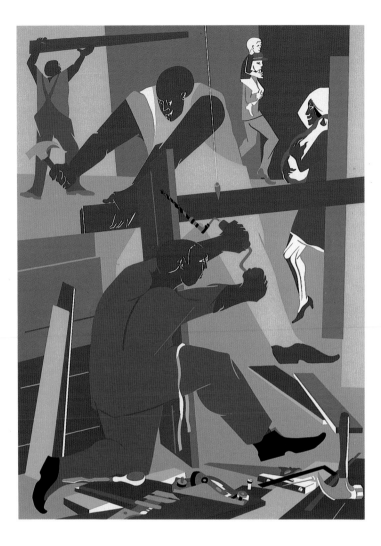

74-2

Builders No. 3

1974

Screenprint on wove paper
From hand-cut film stencils
Edition of 150 with 6 AP
Screens destroyed
Image: 30 × 22 (76.2 × 55.9)
Paper: 34 × 26 (86.3 × 66)

Signed and dated bottom right *Jacob Lawrence 1974*, titled bottom center, numbered bottom left in pencil below the image; no printer's chop mark.

Published by Northside Center for Child Development, Bronx, New York; printed by Ives-Sillman, New Haven, Connecticut.

"I like the symbolism . . . I think of it as man's aspiration, as a constructive tool—man building."

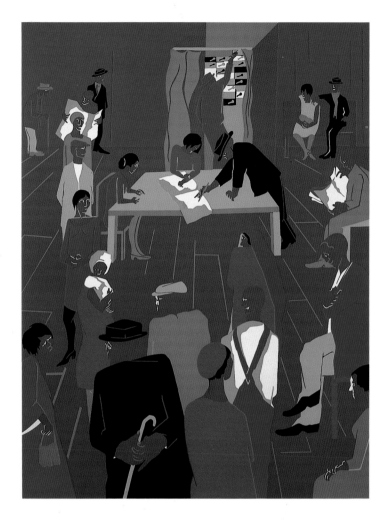

74-3

The 1920's . . . The Migrants Arrive and Cast Their Ballots
1974

Screenprint on Domestic Etching paper
From hand-cut film stencils
Edition of 150 with 15 AP
Screens destroyed
Image: 32 × 24¼ (81.2 × 61.6)
Paper: 34½ × 26 (87.6 × 66)

Signed and dated bottom right *Jacob Lawrence 1974,* titled bottom center, numbered bottom left in pencil below the image; printer's chop mark bottom right.

Published by Lorillard Tobacco Company, New York; printed by Ives-Sillman, New Haven, Connecticut.

Also printed as a poster.

This print was included in *Kent Bicentennial Portfolio: Spirit of Independence* (1975), a portfolio of prints by twelve artists commissioned for the American Bicentennial by the Kent Bicentennial Program. Each artist was asked to make a print in response to the question: "What does independence mean to me?" Other artists whose work is included in the portfolio are Will Barnet, Colleen Browning, Audrey Flack, Red Grooms, Joseph Hirsch, Robert Indiana, Alex Katz, Marisol (Escobar), Larry Rivers, Edward Ruscha, and Fritz Scholder.

In 1940–41 Lawrence, whose parents participated in the migration, executed sixty paintings for a series entitled The Migration of the Negro, to which this print is thematically related.

"During the post World War I period millions of black people left southern communities in the United States and migrated to northern cities. This migration reached its peak during the 1920's. Among the many advantages the migrants found in the north was the freedom to vote. In my print, migrants are represented expressing that freedom."

75-1

People in Other Rooms*
1975

Screenprint on wove paper
From hand-cut film stencils
Edition of 150 with 10 AP
Screens destroyed
Image: 24½ × 18½ (62.2 × 47)
Paper: 30⅜ × 22¼ (77.1 × 56.5)

Signed and dated bottom right *Jacob Lawrence 1975*, titled bottom center, numbered bottom left in pencil below the image; no printer's chop mark.

Published by the Harlem School of the Arts, New York; printed by Ives-Sillman, New Haven, Connecticut.

*Variously titled *People in Other Rooms, Other Rooms;* has also been identified as *Harlem Street Scene.*

"I grew up in New York City. I guess when you grow up in any city you become familiar with doorways and windows and looking through windows. I like the architectonic, geometric shapes of these things. I use these forms over and over again. I don't have any symbolism for them. I imagine that much of our symbolism comes from our experience. Had I been born in the country, maybe I would use a different kind of form. It's always used as a backdrop, a prop, for my imagery."

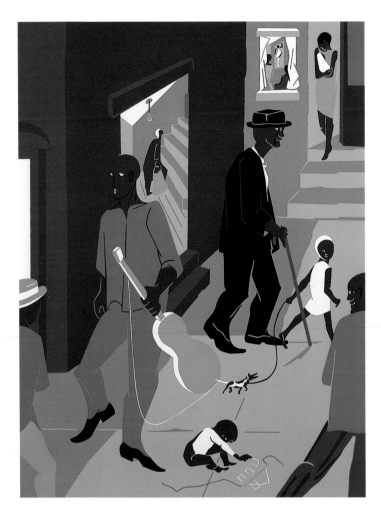

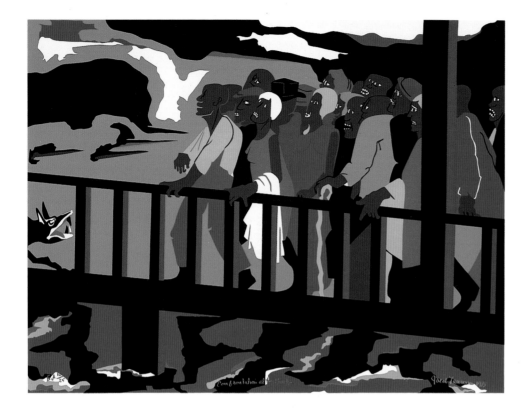

75-2

Confrontation at the Bridge

1975

Screenprint on Strathmore paper
From hand-cut film stencils
Edition of 175 with 25 AP, 25 EA, 25 HC, 1 TP and a deluxe edition
of 50 (numbered in roman numerals, I/L–L/L)
Screens destroyed
Image: 19½ × 25⅞ (49.5 × 65.7)
Paper: 19½ × 25⅞ (49.5 × 65.7)

Signed and dated bottom right *Jacob Lawrence 1975*, titled bottom center, numbered bottom left in pencil on the image; no printer's chop mark.

Published by Transworld Art, New York; printed by Ives-Sillman, New Haven, Connecticut.

This print was included in one of three portfolios that accompanied the ten-volume *An American Portrait 1776–1976*, which was published on the occasion of the American Bicentennial. Each portfolio contained eleven limited edition prints, each by a different artist, and a limited edition three-dimensional object. The portfolio in which this print was included was titled Not Songs of Loyalty Alone: The Struggle for Personal Freedom. The other two portfolios were also thematically determined.

In 1965 hundreds of civil rights marchers left Selma, Alabama, on a peace march to Montgomery. Just outside Selma, at the Edmond Pettus Bridge, the marchers were met with resistance from local law enforcement officials and townspeople. The marchers, led by the Reverend Martin Luther King, Jr., and others, were repeatedly turned back. After several days of stalemate and verbal and physical abuse, the determined marchers were allowed to continue. Regarding the choice of subject matter for this work, Lawrence has commented: "I thought it was part of the history of the country, part of the history of our progress; not of just the black progress, but of the progress of the people."

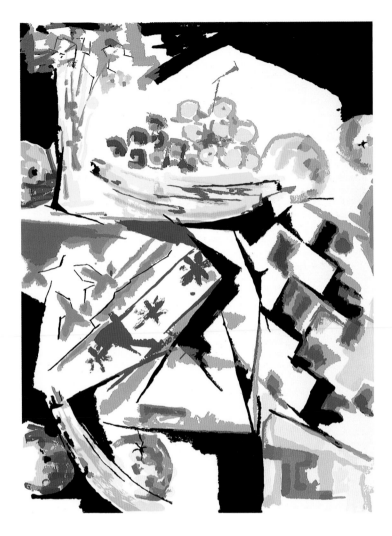

76-1

Morning Still Life

1976

Screenprint on Arches 88 paper
From hand color-separated photo stencils
Edition of 200 with 15 AP, 3 HC
Screens destroyed
Image: 24 × 17½ (61 × 44.5)
Paper: 29¾ × 22¼ (75.5 × 56.5)

Signed and dated bottom right *Jacob Lawrence 1976*, titled bottom center, numbered bottom left in pencil below the image; printer's chop mark bottom left.

Published by Rainbow Art Foundation, New York; printed by Soho Graphic Arts Workshop, New York (Xavier H. Rivera, master printer).

The Rainbow Art Foundation was established to assist young, talented printmakers in the making, marketing, and exhibition of their work. The foundation was conceived by Lawrence, Romare Bearden, Bill E. Caldwell, and Willem de Kooning. Particular attention was given to supporting artists whose work did not receive deserved support by the art world (especially artists of Asian, African, Hispanic, and Native American backgrounds). This print was executed as a fund-raiser for the foundation.

Although Lawrence frequently incorporates still-life images into his figurative compositions, rarely, as with Morning Still Life, *does he use that genre for a complete work. The painted original for this print is also extraordinary as an example of the artist's rare use of watercolor: "Once in a while I will do a watercolor. I like the looseness of it, because otherwise my work is so tight, so hard edged. I like to do this to do something different. I think the structure is the same."*

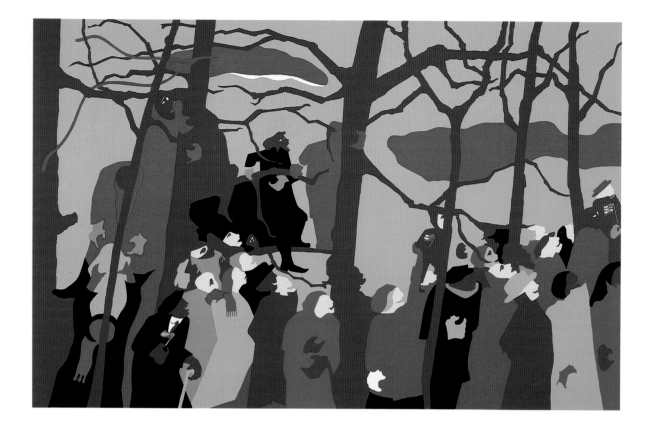

77-1

The Swearing In
1977

Screenprint on wove paper
From hand-cut film stencils
Edition of 100 with 20 AP, 12 HC
Image: 18 × 28 (45.7 × 71.1)
Paper: 20 × 30 (50.8 × 76.1)

Signed and dated bottom right *Jacob Lawrence 1977,* titled bottom center, numbered bottom left in pencil below the image; no printer's chop mark.

Published by the Presidential Inaugural Committee, Washington, D.C.; printed by the Screenprint Workshop, East Hampton, New York (Arnold Hoffman, master printer).

This print was commissioned for a portfolio entitled Inaugural Impressions, which included prints by four other artists: Roy Lichtenstein, Robert Rauschenberg, Andy Warhol, and Jamie Wyeth. Each print was based on the inaugural ceremonies of January 1977. Lawrence made two paintings for the commission: *The Swearing In #1* and *The Swearing In #2;* the former was used as the model for the screenprint.

"When Carter said he wanted this to be a 'people's inauguration,' it was that. As we sat, when he was taking the oath of office, I looked behind me and way in the distance there were bare trees and people were up in these trees and they were applauding more than the people in the immediate area, who I imagined were the people with special privileges. The bare trees . . . and limbs—you could see the people up there, and then you could hear this muffled sound from a great distance. I see it as the most important ingredient of the election and the inauguration, and that's the people themselves."

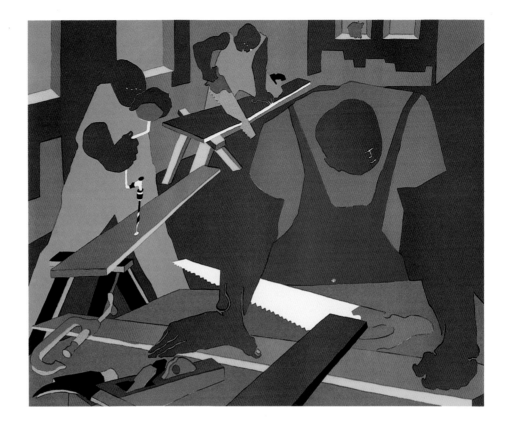

77-2

Carpenters

1977

Offset lithograph on Rives BFK paper
From aluminum plates hand drawn by the artist
Edition of 300 with 10 AP, 5 HC
Plates destroyed
Image: 18½ × 22 (47 × 55.8)
Paper: 21¾ × 25¾ (55.2 × 65.4)

Signed and dated bottom right *Jacob Lawrence 1977*, titled bottom center,
numbered bottom left in pencil below the image; no printer's chop mark.

Published by Himan Brown, New York; printed by George C. Miller & Son,
New York (Burr Miller, master printer).

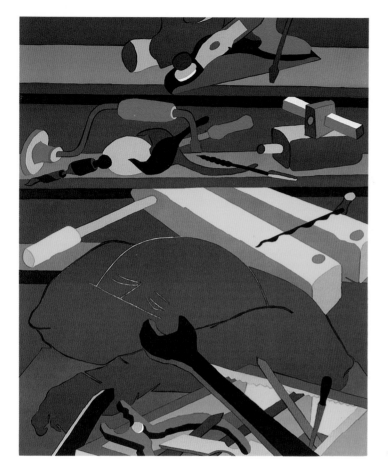

77-3

Tools

1977

Offset lithograph on Rives BFK paper
From aluminum plates hand drawn by the artist
Edition of 300 with 10 AP, 5 HC
Plates destroyed
Image: 21⅞ × 18⅛ (55.6 × 46)
Paper: 26 × 21¾ (66 × 55.2)

Signed and dated bottom right *Jacob Lawrence 1977*, titled bottom center, numbered bottom left in pencil below the image; no printer's chop mark.

Published by Himan Brown, New York; printed by George C. Miller & Son, New York (Burr Miller, master printer).

Note: 104/300 misdated 1947.

"It's a beautiful instrument, the tool, especially the hand-tool. We pick it up and it's so perfect, it's so ideal, it's so utilitarian, so aesthetic, that we turn it, we look at it. If it has been around quite some time, it takes on a certain patina, which is really very beautiful. And it's like an extension of the hand. I always think of the tool as an extension of the hand."

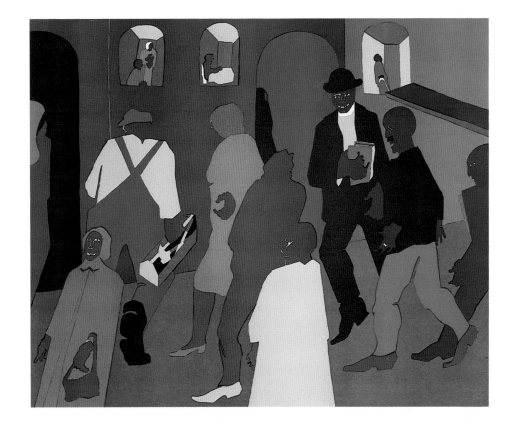

77-4

Windows

1977

Offset lithograph on Rives BFK paper
From aluminum plates hand drawn by the artist
Edition of 300 with 10 AP, 5 HC
Plates destroyed
Image: 17¾ × 22 (45.1 × 55.9)
Paper: 21¾ × 25½ (55.2 × 64.8)

Signed and dated bottom right *Jacob Lawrence 1977*, titled bottom center,
numbered bottom left in pencil below the image; no printer's chop mark.

Published by Himan Brown, New York; printed by George C. Miller & Son,
New York (Burr Miller, master printer).

*"I grew up in a community where we would see the same faces, and you
thought that you knew everyone in the community. People at that time
weren't as mobile as they are now. You didn't know them to speak to
them, but you would see the same faces over and over again."*

77-5

The Legend of John Brown

1977

Twenty-two screenprints on Domestic Etching paper
From hand-cut film stencils
Edition of 60 with 20 HC
Screens destroyed
Image: 20 × 14 (50.8 × 35.6)
 14 × 20 (35.6 × 50.8)
Paper: 25⅞ × 20 (65.7 × 50.8)
 20 × 25⅞ (50.8 × 65.7)

Each print signed and dated bottom right *Jacob Lawrence 1977*, numbered bottom left in pencil below the image; printer's chop mark bottom right, publisher's chop mark bottom right. The portfolio includes a previously unpublished poem by Robert Hayden entitled "John Brown" and is signed on the imprint page by both Lawrence and Hayden.

Published by the Founders Society of the Detroit Institute of Arts, Detroit, Michigan; printed by Ives-Sillman, New Haven, Connecticut.

The prints are based on the gouache paintings from the 1941 John Brown series in the permanent collection of the Detroit Institute of Arts. Because of the unstable condition of the original paintings, DIA commissioned Ives-Sillman to transfer the images to screenprints, to allow greater accessibility to Lawrence's narrative. The prints are the same size as the painted originals. Each painting was originally exhibited with text written by the artist.

With the support of northern abolitionists and his own strong religious convictions, John Brown organized a series of successful covert missions to liberate slaves from southern plantations. In the mid-1850s Brown led antislavery troops in an effort to keep Kansas a free state. Brown was later captured during a raid on Harpers Ferry and convicted of treason. He was hung in 1859 in Charles Town, Virginia (now West Virginia).

"The inspiration to paint the Frederick Douglass, Harriet Tubman and John Brown series was motivated by historical events as told to us by the adults of our community . . . the black community. The relating of these events, for many of us, was not only very informative but also most exciting to us, the men and women of these stories were strong, daring and heroic; and therefore we could and did relate to these by means of poetry, song and paint."

No. 1. John Brown, a man who had a fanatical belief that he was chosen by God to overthrow black slavery in America.

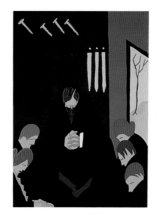

No. 2. For 40 years, John Brown reflected on the hopeless and miserable condition of the slaves.

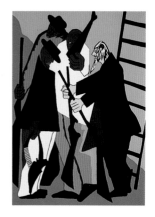

No. 6. John Brown formed an organization among the colored people of the Adirondack woods to resist the capture of any fugitive slave.

No. 10. Those pro-slavery were murdered by those anti-slavery.

No. 3. For 12 years, John Brown engaged in land speculations and wool merchandising; all this to make some money for his greater work which was the abolishment of slavery.

No. 4. His adventures failing him, he accepted poverty.

No. 5. John Brown, while tending his flock in Ohio, first communicated with his sons and daughters his plans of attacking slavery by force.

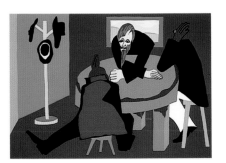

No. 7. To the people he found worthy of his trust, he communicated his plans.

No. 8. John Brown's first thought of the place where he would make his attack came to him while surveying land for Oberlin College in West Virginia.

No. 9. Kansas was now the skirmish ground of the Civil War.

No. 11. John Brown took to guerilla warfare.

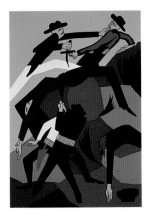

No. 12. John Brown's victory at Black Jack drove those pro-slavery to new fury, and those who were anti-slavery to new efforts.

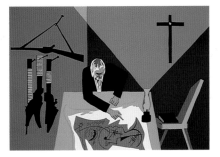

No. 13. John Brown, after long meditation, planned to fortify himself somewhere in the mountains of Virginia or Tennessee and there make raids on the surrounding plantations, freeing slaves.

No. 14. John Brown collected money from sympathizers and friends to carry out his plans.

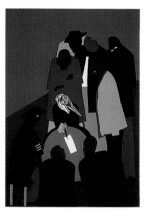

No. 15. John Brown made many trips to Canada organizing for his assault on Harpers Ferry.

No. 16. In spite of a price on his head, John Brown, in 1859, liberated 12 Negroes from Missouri plantations.

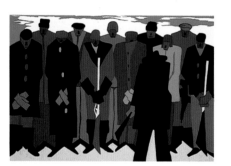

No. 17. John Brown remained a full winter in Canada, drilling Negroes for his coming raid on Harpers Ferry.

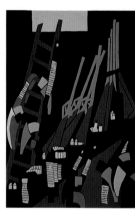

No. 18. July 3, 1859, John Brown stocked an old barn with guns and ammunitions. He was ready to strike his first blow at slavery.

No. 19. Sunday, October 16, 1859, John Brown with a company of 21 men, white and black, marched on Harpers Ferry.

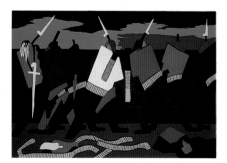

No. 20. John Brown held Harpers Ferry for 12 hours. His defeat was a few hours off.

No. 21. After John Brown's capture, he was put to trial for his life in Charles Town, Virginia (now West Virginia).

No. 22. John Brown was found "Guilty of treason and murder in the 1st degree" and was hanged in Charles Town, Virginia on December 2, 1859.

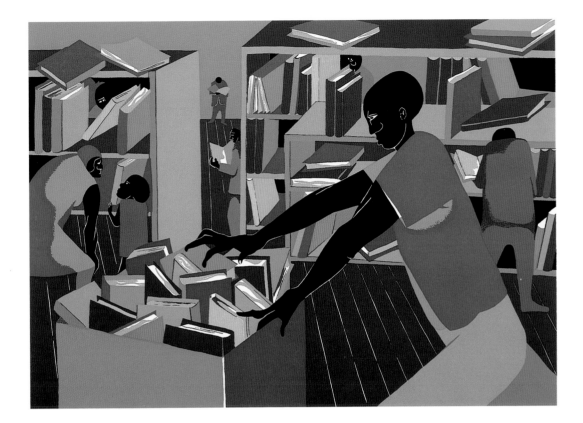

78-1

The Library

1978

Screenprint on wove paper
From hand-cut film stencils
Edition of 100 with 25 AP
Screens destroyed
Image: 10¼ × 15⅛ (26 × 38.4)
Paper: 20¼ × 24 (51.4 × 61)

Signed and dated bottom right *Jacob Lawrence 1978*, titled bottom center, numbered bottom left in pencil below the image; no printer's chop mark.

Published by Five Towns Music and Art Foundation, Woodmere, New York; printed by the Screenprint Workshop, East Hampton, New York (Arnold Hoffman, master printer).

Lawrence taught at Five Towns Music and Art Foundation in Cedarhurst, New York, from 1962 to 1965 and again from 1966 to 1968.

This print is based on a gouache painting executed in 1966. The library theme is also present in earlier paintings, among them: *The Libraries Are Appreciated* (1943), from the Harlem series; *Library II* (1960) and *Library III* (1960).

"I spent quite a bit of my youth in libraries. I was encouraged by my teachers to go to the library, all of us were . . . and it became a living experience for us. I would hear stories from librarians about various heroes and heroines. The library in my day was a very important part of my life."

83-1

Hiroshima
1983

Eight screenprints on Somerset paper
From hand color-separated photo stencils
Edition of 35 with 10 AP, 5 PP
Screens destroyed
Image: 12⅞ × 10 (32.7 × 25.5)
Paper: 14⅞ × 11⅛ (37.8 × 28.2)

Each print signed and dated bottom right *Jacob Lawrence 83*, numbered bottom left in pencil below the image; no printer's chop mark.

Published by the Limited Editions Club, New York; printed by Studio Heinrici, New York (Alexander Heinrici, master printer). The portfolio includes a signed poem by Robert Penn Warren.

Also published as illustrations in *Hiroshima*, a special edition book (edition of 1,500) with text by John Hersey. The book includes the Penn Warren poem and is signed on the colophon page by all three collaborators. Hersey's text was originally published in the *New Yorker*, June 1946.

"Several years ago I was invited by the Limited Editions Club of New York to illustrate a book of my choosing from a list of the club's many titles. I selected the book Hiroshima, *written by the brilliant writer John Hersey. This work was selected because of its power, insight, scope, and sensitivity as well as for its overall content. My intent was to illustrate a series of events that were taking place at the moment of the dropping of the bomb . . . August 6, 1945. The challenge for me was to execute eight works: a marketplace, a playground, a street scene, a park, farmers, a family scene, a man with birds, and a boy with a kite. Not a particular country, not a particular city, and not a particular people.*

" Is it not ironic that we have produced great scientists, great musicians, great orators, chess players, philosophers, poets and great teachers and, at the same time, we have developed the capability and the genius to create the means to devastate and to completely destroy our planet earth with all its life and beauty? How could we develop such creative minds and, at the same time develop such a destructive instrument? Only God knows the answer. Let us hope that some day at some time, He will give us the answer to this very perplexing question."

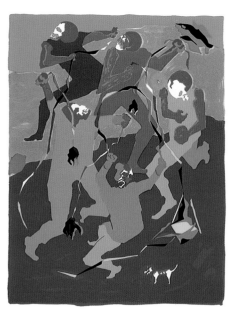

No. 1. Playground

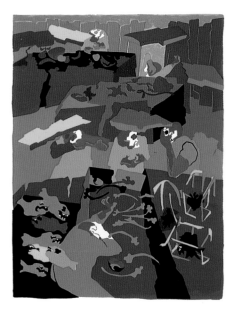

No. 5. Market

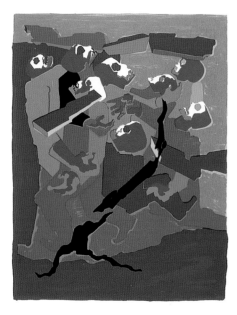

No. 2. Street Scene

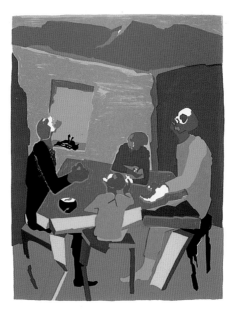

No. 3. Family

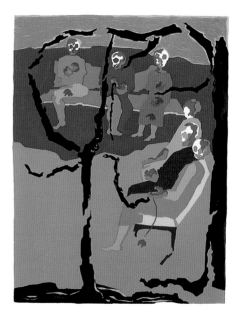

No. 4. People in the Park

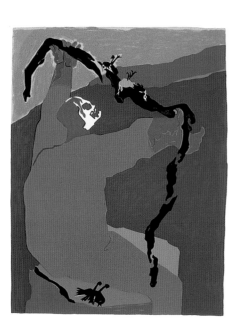

No. 6. Man with Birds

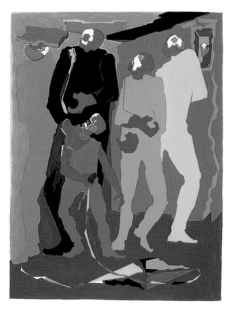

No. 7. Boy with Kite

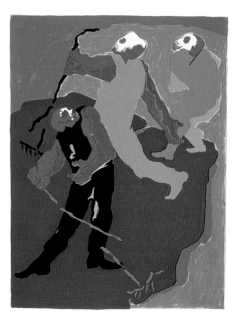

No. 8. Farmers

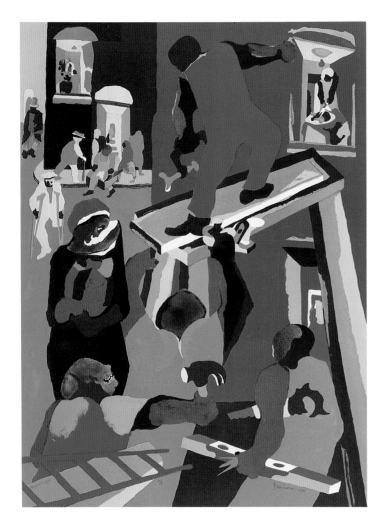

85-1

Man on Scaffold

1985

Lithograph on Arches paper
From hand-drawn aluminum plates
Edition of 60 with 6 AP, 2 PP
Plates destroyed
Image: 30 × 22½ (76.2 × 57.1)
Paper: 30 × 22½ (76.2 × 57.1)

Signed and dated bottom right *Jacob Lawrence 1985*, titled bottom left, numbered bottom center in pencil on the image; printer's chop mark bottom right.

Published by Francine Seders Gallery, Seattle; printed by Stone Press Editions, Seattle (Kent Lovelace, master printer).

Lawrence relates the recurrence of ladders and scaffolding in his paintings and prints to the fire escapes that decorated the urban environment of his early years: "When my family arrived in New York in 1930 the thing that I was very impressed with were the fire escapes of the tenements, which you saw a lot of in New York. You don't see a lot of them these days because you don't have tenements like that here [in Seattle]. In the new housing they put the fire escapes on the inside. I think I was so impressed by this that this form appears throughout my work, as part of building the composition. I don't even think about it, it's just part of it."

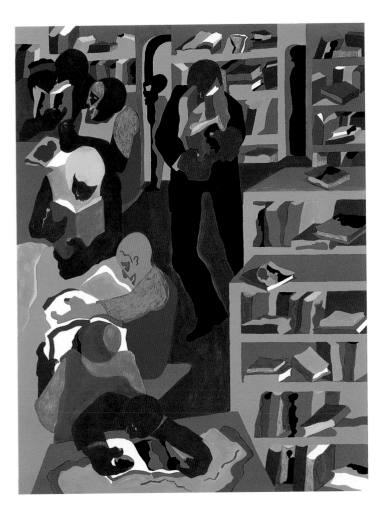

87-1

Schomburg Library

1987*

Lithograph on Arches paper
From hand-drawn aluminum plates
Edition of 200 with 20 AP, 10 PP, 20 HC
Plates destroyed
Image: 26 × 20 (66 × 50.8)
Paper: 33¼ × 23½ (84.5 × 59.7)

Signed and dated bottom right *Jacob Lawrence 1987*, titled bottom center, numbered bottom left in pencil below the image; printer's chop mark bottom left.

Published by the Schomburg Center for Research in Black Culture, New York, on the occasion of its sixtieth anniversary (1926–1986) to commemorate the legacy of Arthur Schomburg; printed by JK Fine Art Editions, Union City, New Jersey (Joseph Kleineman and Maureen Turci, master printers).

*HC proofs dated 1986

Also printed as a poster.

The 135th Street YMCA in New York City was one of the focal points of the black community in Harlem during the 1920s and '30s, offering countless cultural events and the largest accumulation of black studies materials in the world. Lawrence did much of the research for his paintings there during the 1930s, '40s, and '50s. Today the library is known as the Schomburg Center for Research in Black Culture. This print contains several references to the nature of the collection, including the silhouette of Harriet Tubman, which is visible on the jacket of one of the books.

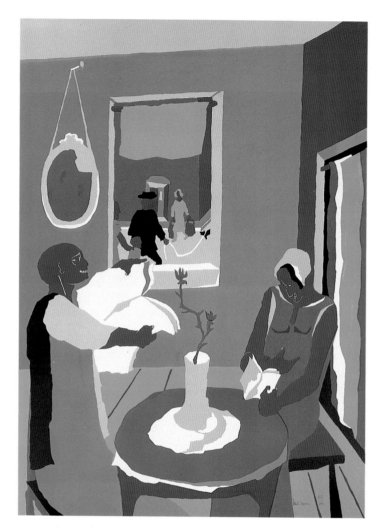

88-1

Aspiration
1988

Lithograph on Arches paper
From hand-drawn aluminum plates
Edition of 200 with 20 AP, 6 PP
Plates destroyed
Image: 29¼ × 21⅜ (74.2 × 54.2)
Paper: 29¼ × 21⅜ (74.2 × 54.2)

Signed and numbered bottom right in pencil on the image; printer's chop mark bottom right.

Published by the NAACP Special Contribution Fund on the occasion of its eightieth anniversary; printed at Stone Press Editions, Seattle (Kent Lovelace, master printer).

"What did I see when I arrived in Harlem in 1930? I was thirteen years of age. I remember seeing the movement, the life, the people, the excitement. We were going through a great, great depression at that time, but despite that, I think there was always hope. We lived through a hope that tomorrow there would be another quart of milk on the table, there would be another loaf of bread on the table, we'd be able to pay the rent. I was a youngster at the time—our parents were going through this—but as far as I can remember, there was always this hope, a feeling of uplift."

89-1

To the Defense

1989

Lithograph on Arches paper
From hand-drawn aluminum plates
Edition of 200 with 20 AP, 6 PP
Plates destroyed
Image: 31⅞ × 24 (81 × 61)
Paper: 31⅞ × 24 (81 × 61)

Signed and dated bottom right *Jacob Lawrence © 89*, titled bottom center, numbered bottom left in pencil on the image; printer's chop mark bottom left.

Published by the NAACP Legal Defense and Educational Fund on the occasion of its fiftieth anniversary; printed by Stone Press Editions, Seattle (Kent Lovelace, master printer).

Also printed as a poster.

"All through our history, we—black people especially—have depended on the law to defend us, [though] not always getting the best results. . . . [Here] I tried to show that the lawyer was a very important symbol of something, even beyond the law."

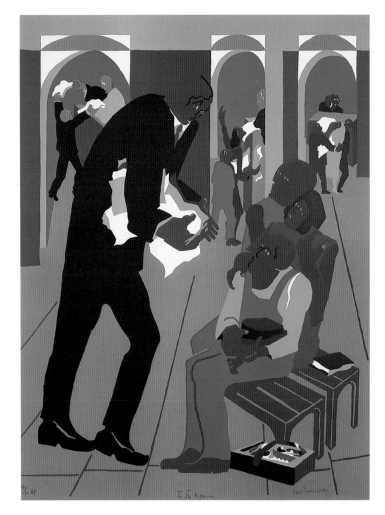

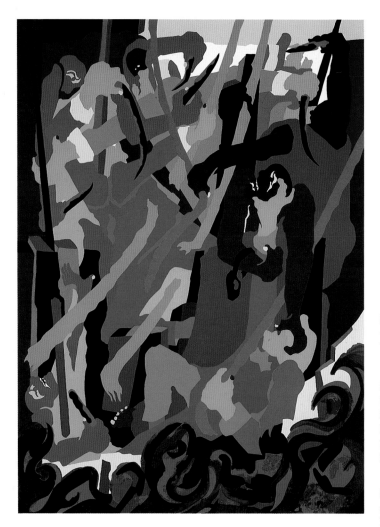

89-2

Revolt on the Amistad

1989

Screenprint on Bainbridge 2-ply paper
From hand-cut film and brushed-lacquer stencils
Edition of 120 with 30 AP, 10 PP, 14 WP, 10 CP
Screens destroyed
Image: 35 × 25⅝ (88.9 × 65.1)
Paper: 40⅛ × 32⅛ (102 × 81.6)

Signed and dated bottom right *Jacob Lawrence 1989*, titled bottom center, numbered bottom left in pencil below the image; printer's chop mark bottom left.

Published by the Aetna Life Insurance Company and Spradling-Ames, Key West, Florida, on the 150th anniversary of the Amistad incident; printed by Workshop, Inc., Washington, D.C. (Lou Stovall, master printer).

Also printed as a poster.

In 1839, fifty-three enslaved Mendian Africans revolted and held control of the Spanish slave ship La Amistad until their capture several months later in U.S. waters. American abolitionists fought for freedom for the Mendians, and after the case was heard by the U.S. Supreme Court, the Mendians were granted freedom. Two years later, the abolitionists arranged for the return to Sierra Leone of the surviving thirty-five Mendians, accompanied by American missionaries and teachers.

90-1

On the Way

1990

Lithograph on Rives BFK paper
From hand-drawn aluminum plates
Edition of 100 with 10 AP, 6 PP, 10 HC
Plates destroyed
Image: 39 × 29⅝ (99 × 75.2)
Paper: 39 × 29⅝ (99 × 75.2)

Signed and dated bottom right *Jacob Lawrence 1990*, numbered bottom left in pencil on the image; printer's chop mark bottom right.

Published by the Resident Associate Program of the Smithsonian Institution, Washington, D.C., on the occasion of its twenty-fifth anniversary; printed by Stone Press Editions, Seattle (Kent Lovelace, master printer).

Lawrence has depicted pool halls in several paintings, including: *Pool Parlor* (1942) and *The Pool Game* (1970).

"On the Way *was commissioned by the Smithsonian Institution Resident Associate Program. I did not have to deal with a specific theme and so chose to do a Harlem street scene, a subject I have frequently worked with over the years. These scenes are taken in a general sense from my memories of growing up in the Harlem community in the 1930s. The strolling couple, running boy, and pool room interior all appear often in my work.*"

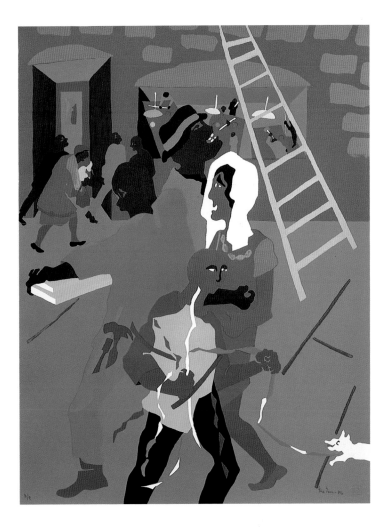

90-2

Eight Studies for the Book of Genesis
1990

Eight screenprints on Whatman Print Matt paper
From hand color-separated photo stencils
Edition of 50 with 8 AP, 2 PP, 6 HC, 1 BAT, 1 AR, 1 CL
Screens destroyed
Image: 19⅝ × 14⅜ (49.8 × 36.5)
Paper: 25 × 19⅛ (63.5 × 48.6)

Each print signed bottom right, numbered bottom left in pencil below
the image; no printer's chop mark.

Published by the Limited Editions Club, New York; printed at Osiris
Screen Printing, New York (George Drexel, master printer).

Also printed in two additional formats:

Exhibition portfolio
Edition of 22 with 5 AP, 2 PP, 4 HC, 1 TP, 1 BAT, 1 AR, 1 CL
Image: 19⅝ × 14⅜ (49.8 × 36.5)
Paper: 26 × 40 (66 × 101.6)

Each print signed and inscribed in manner consistent with regular edition.

Portfolio titled *Eight Passages*. Each screenprint trimmed to image and
chine colléed onto right-hand side of St. Armand paper bearing captions
lithographed on left side from mylars hand written by the artist. Lithography and chine collée by Stone Press Editions, Seattle (Kent Lovelace,
master printer).

Book
Edition of 400 with 50 HC

Each print signed by artist.

The prints illustrate and accompany the King James version of the book
of Genesis.

Note: The full edition information in both portfolio editions incorrectly
states that the book edition consisted of 425 copies.

*"I was baptized in the Abyssinian Baptist Church [in Harlem] in about 1932.
There I attended church, I attended Sunday School, and I remember the
ministers giving very passionate sermons pertaining to the Creation. This was
over fifty years ago, and you know, these things stay with you even though
you don't realize what an impact these experiences are making on you at the
time. As I was doing the series I think that this was in the back of my mind,
hearing this minister talk about these things."*

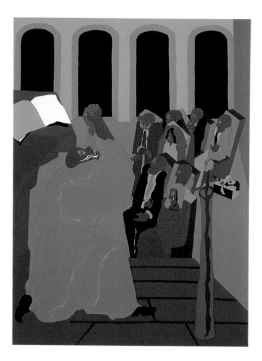

No. 1. "In the beginning all was void."

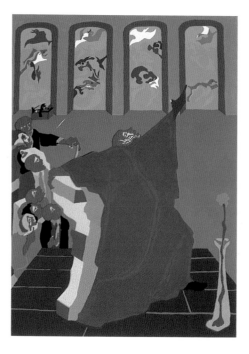

No. 5. "And God created all the fowls of the air
and fishes of the seas."

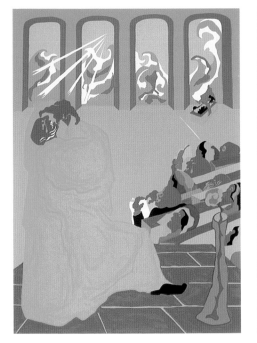

No. 2. "And God brought forth the firmament and the waters."

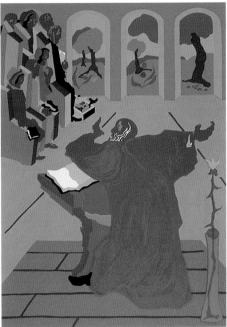

No. 3. "And God said 'Let the Earth bring forth the grass, trees, fruits, and herbs.'"

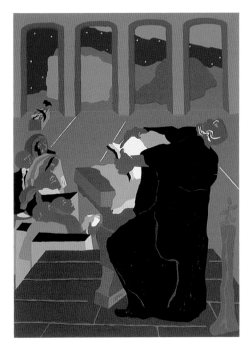

No. 4. "And God created the day and the night and God created and put stars in the skies."

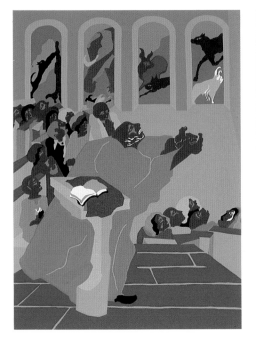

No. 6. "And God created all the beasts of the earth."

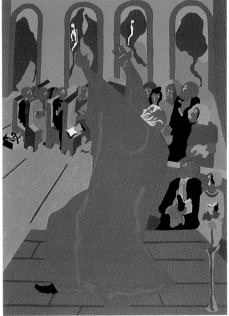

No. 7. "And God created man and woman."

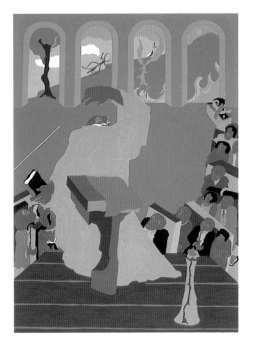

No. 8. "The Creation was done—and all was well."

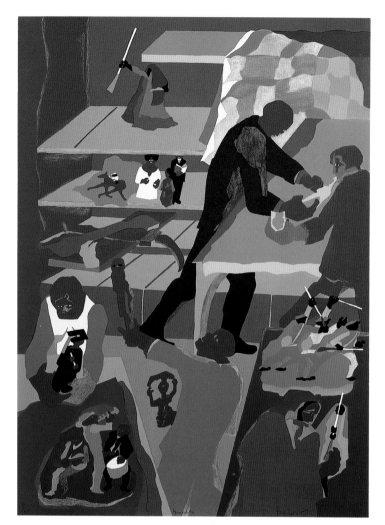

90-3

Memorabilia

1990

Lithograph on Rives BFK paper
From hand color-separated photo aluminum plates
Edition of 100 with 10 AP, 5 HC
Plates destroyed
Image: 31¼ × 22⅞ (79.3 × 58.1)
Paper: 31¼ × 22⅞ (79.3 × 58.1)

Signed bottom right, titled bottom center, numbered bottom left in pencil on the image; printer's chop mark bottom right.

Published by University of Washington Press, Seattle; printed at Stone Press Editions, Seattle (Kent Lovelace, master printer).

Also printed as a poster.

Originally commissioned in 1989 by Vassar College as a poster for the twentieth anniversary of its Africana Studies Program. The lithograph was published by University of Washington Press to establish the Jacob Lawrence Endowment. The fund is being used to support a new series of publications entitled the Jacob Lawrence Series on American Artists.

For the twentieth anniversary of Vassar College's Program in Africana Studies, Lawrence chose to depict the storeroom of a conservatory replete with images of an African American heritage. Visible are examples of African carving, a Nigerian adire cloth, and a jazz trio. Historical events, alluding in part to Lawrence's own previous work, are also represented. On the top shelf, Harriet Tubman brandishes a rifle, while on the table several troops allude to such revolutionary armies as those of Toussaint L'Ouverture and John Brown or to the battles of the Civil War.

91-1

Builders Three

1991

Offset lithograph on Arches paper
From photo aluminum plates; mylars hand drawn by the artist
Edition of 90 with 25 AP, 8 PP
Plates destroyed
Image: 30 × 21¾ (76.2 × 55.2)
Paper: 30 × 21¾ (76.2 × 55.2)

Signed and dated bottom right *Jacob Lawrence 10/1/91*, titled bottom center, numbered bottom left in pencil on the image; no printer's chop mark.

Published and printed by Brandywine Workshop, Philadelphia (Robert Franklin, master printer).

In 1991 Lawrence received the James Van Der Zee Award, a national award presented annually by the Brandywine Workshop to distinguished African American artists. A special residency at the Offset Institute of the Brandywine Workshop was included among the awarded benefits.

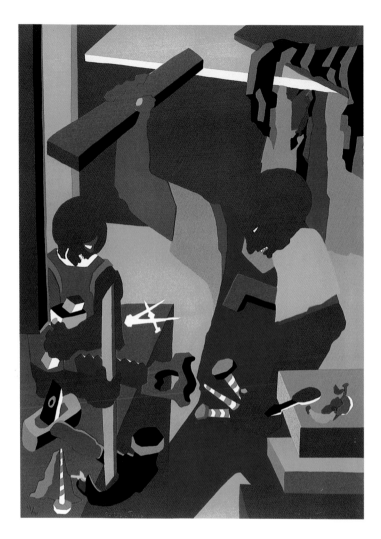

92-1

Celebration of Heritage

1992

Lithograph on Rives BFK paper
From hand color-separated photo aluminum plates
Edition of 150 with 3 PP, 3 HC
Plates destroyed
Image: 30 × 22¼ (76.1 × 56.5)
Paper: 30 × 22¼ (76.1 × 56.5)

Signed and dated bottom right *Jacob Lawrence 92*, titled bottom left, numbered bottom center in pencil on the image; printer's chop mark bottom right.

Published jointly by the American Indian Heritage Foundation, Falls Church, Virginia, and Francine Seders Gallery, Seattle; printed by Stone Press Editions, Seattle (Kent Lovelace, master printer).

Published to support the American Indian Heritage Foundation and to coincide with the exhibition *Artists for American Indians*, at the 1992 World's Fair Exposition (EXPO '92) in Seville, Spain.

"I'm not talking about the black experience here; I'm talking about another kind of experience, the Native American experience—the beauty of it, the poetry of people being a part of nature. This is the way many Native Americans think of themselves—not as separate from, but a part of, nature. . . . I think of it as part of my Builders series [in which] the tool is an extension of the hand. Instead of tools here, I use the elements."

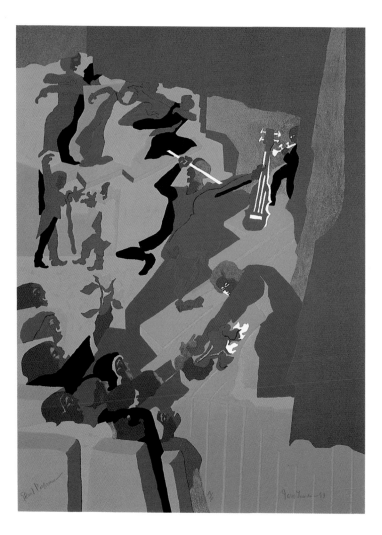

93-1

Grand Performance

1993

Lithograph on Rives BFK paper
From hand color-separated photo aluminum plates
Edition of 150 with 15 AP, 5 PP, 1 HC
Plates destroyed
Image: 26½ × 20¼ (67.3 × 51.5)
Paper: 26½ × 20¼ (67.3 × 51.5)

Signed and dated bottom right *Jacob Lawrence 93*, titled bottom left, numbered bottom center in pencil on the image; printer's chop mark bottom right.

Published by Anheuser-Busch Companies, St. Louis; printed by Stone Press Editions, Seattle (Kent Lovelace, master printer).

Also printed as a poster.

Published on the occasion of the 1993 NAACP Image Awards 25th Anniversary celebration. The posters were printed as part of the NAACP fundraiser for its Stay in School program.

This print relates thematically to the Theater series (1951–52).

"We had a very famous theater in Harlem called the Vaudeville House [the Apollo]. Every two weeks they would have a stage show and a movie, and it became part of our recreation. We would go there to see the comedians, the chorus lines, the dance, performance. I knew that's what they were thinking of, the people who commissioned [this print], in terms of the performing arts. All of these things come out of my own experience."

Toussaint L'Ouverture series
1986–1993

The Birth of Toussaint L'Ouverture, 1986
General Toussaint L'Ouverture, 1986
The Capture, 1987
To Preserve Their Freedom, 1988
Toussaint at Ennery, 1989
The Coachman, 1990
Dondon, 1992
Contemplation, 1993

These prints are based on forty-one paintings from a series also entitled Toussaint L'Ouverture, which was completed in 1938 and is now in the Aaron Douglas Collection of the Amistad Research Center, New Orleans. The paintings were executed in tempera and measure 11 × 19 inches, significantly smaller in scale than the prints. Lawrence reworked many of the images during the process of translating them to silk screen. When an image has been significantly altered from the original, that fact is noted in the catalogue entry. The captions Lawrence provided for the paintings at the time of their execution accompany each of the following entries.

Toussaint L'Ouverture was a leader in the Haitian revolution. Born a slave, he rose to become commander in chief of the revolutionary army. In 1800 he coordinated the effort to draw up Haiti's first democratic constitution. However, in 1802, before the Republic was firmly established, Toussaint was arrested by Napoléon Bonaparte's troops and sent to Paris, where he was imprisoned. He died in prison the following year. In 1804 Haiti became the first black Western republic.

No. 6. The birth of Toussaint L'Ouverture, May 20, 1743.

Toussaint L'Ouverture series

86-1

The Birth of Toussaint L'Ouverture
1986

Screenprint on Bainbridge 2-ply paper
From hand-cut film stencils
Edition of 100 with 25 AP, 10 HC, 5 WP
Screens destroyed
Image: 28½ × 18½ (72.4 × 47)
Paper: 32⅛ × 22 (81.5 × 55.9)

Signed and dated bottom right *Jacob Lawrence 1986*, titled bottom center *The Birth of Toussaint*, numbered bottom left in pencil below the image; printer's chop mark bottom left.

Published by the Amistad Research Center, New Orleans; printed by Workshop, Inc., Washington, D.C. (Lou Stovall, master printer).

This print is based on the sixth image from the original series of forty-one paintings.

Toussaint L'Ouverture series

86-2

General Toussaint L'Ouverture
1986

Screenprint on Bainbridge 2-ply paper
From hand-cut film and brushed-lacquer stencils
Edition of 100 with 25 AP, 10 HC, 7 WP
Screens destroyed
Image: 28⅜ × 18½ (72.1 × 47)
Paper: 32⅛ × 22 (81.6 × 55.9)

Signed and dated bottom right *Jacob Lawrence 1986*, titled bottom center
L'Ouverture, numbered bottom left in pencil below the image; printer's
chop mark bottom left.

Published by the Amistad Research Center, New Orleans; printed by
Workshop, Inc., Washington, D.C. (Lou Stovall, master printer).

This print is based on the twentieth image from the original series of
forty-one paintings.

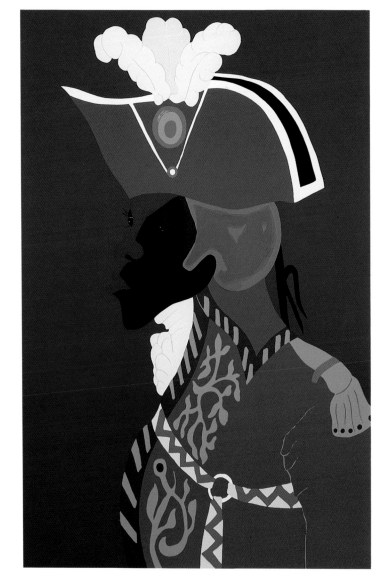

No. 20. General Toussaint L'Ouverture, Statesman and military Genius,
esteemed by the Spaniards, feared by the English, dreaded by the French,
hated by the planters, and reverenced by the Blacks.

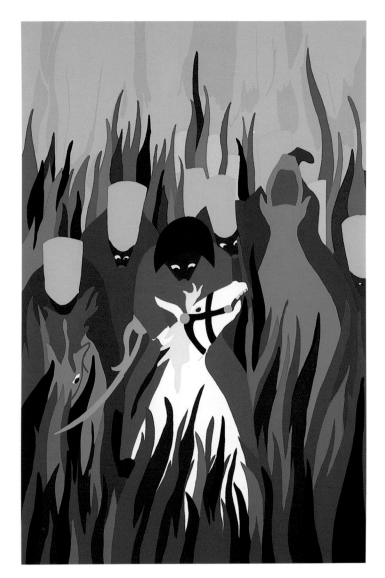

No. 17. Toussaint captured Marmelade, held by Vernet, a mulatto, 1795.

Toussaint L'Ouverture series

87-2

The Capture

1987

Screenprint on Bainbridge 2-ply paper
From hand-cut film stencils
Edition of 120 with 30 AP, 18 PP, 13 WP, 10 CP
Screens destroyed
Image: 28¼ × 18⅜ (71.8 × 46.7)
Paper: 32⅛ × 22 (81.6 × 55.9)

Signed and dated bottom right *Jacob Lawrence 1987*, titled bottom center, numbered bottom left in pencil below the image; printer's chop mark bottom left.

Published by the Amistad Research Center, New Orleans; printed by Workshop, Inc., Washington, D.C. (Lou Stovall, master printer).

This print is based on the seventeenth image from the original series of forty-one paintings.

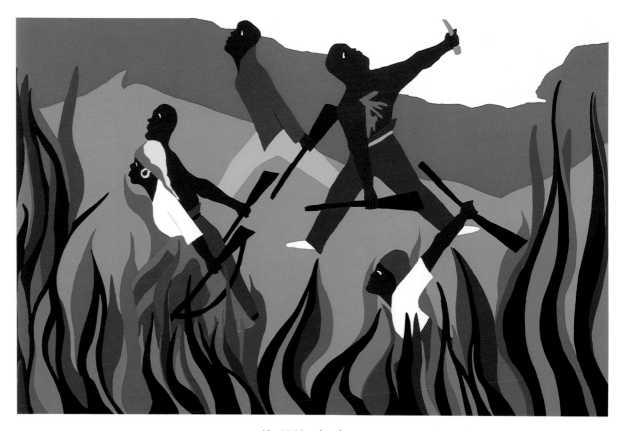

No. 38. Napoleon's attempt to restore slavery in Haiti was unsuccessful. Desalines, Chief of the Blacks, defeated LeClerc. Black men, women, and children took up arms to preserve their freedom, November, 1802.

Toussaint L'Ouverture series

88-2

To Preserve Their Freedom
1988

Screenprint on Bainbridge 2-ply paper
From hand-cut film stencils
Edition of 99 with 25 AP, 10 PP, 10 WP, 18 CP
Screens destroyed
Image: 18½ × 28¾ (47 × 73)
Paper: 22 × 32⅛ (55.9 × 81.6)

Signed and dated bottom right *Jacob Lawrence 1988,* titled bottom center, numbered bottom left in pencil below the image; printer's chop mark bottom left.

Published by the Amistad Research Center, New Orleans, and Spradling-Ames, Key West, Florida; printed by Workshop, Inc., Washington, D.C. (Lou Stovall, master printer).

This print is based on the thirty-eighth image from the original series of forty-one paintings. The image differs significantly from the original painting. Lawrence added the wound to the central figure, reconfigured the sky and foliage, and incorporated bright red and yellow into the composition.

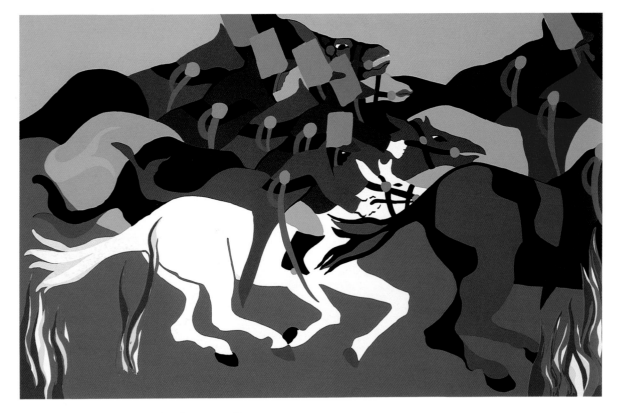

No. 34. Toussaint defeats Napoleon's troups at Ennery.

Toussaint L'Ouverture series

89-3

Toussaint at Ennery
1989

Screenprint on Bainbridge 2-ply paper
From hand-cut film stencils
Edition of 99 with 25 AP, 18 PP, 20 WP, 35 CP
Screens destroyed
Image: 18⅝ × 29 (47.3 × 73.7)
Paper: 22 × 32⅛ (55.9 × 81.6)

Signed and dated bottom right *Jacob Lawrence 1989*, titled bottom center, numbered bottom left in pencil below the image; printer's chop mark bottom left.

Published by the Amistad Research Center, New Orleans, and Spradling-Ames, Key West, Florida; printed at Workshop, Inc., Washington, D.C. (Lou Stovall, master printer).

This print is based on the thirty-fourth image from the original series of forty-one paintings. Though several changes have been made to the forms of the horses and riders, the most significant alterations are in the palette. The colors of the ground, sky, hats, and sabres have been altered. Lawrence added red, blue, and yellow to the composition, turning the foliage in the foreground to flames.

Toussaint L'Ouverture series

90-4

The Coachman
1990

Screenprint on Bainbridge 2-ply paper
From hand-cut film stencils
Edition of 99 with 24 AP, 8 PP, 14 WP, 6 CP
Screens destroyed
Image: 28¼ × 18⅜ (71.7 × 46.7)
Paper: 32⅛ × 22 (81.6 × 55.9)

Signed and dated bottom right *Jacob Lawrence 1990,* titled bottom center, numbered bottom left in pencil below the image; printer's chop mark bottom left.

Published by the Amistad Research Center, New Orleans, and Spradling-Ames, Key West, Florida; printed by Workshop, Inc., Washington, D.C. (Lou Stovall, master printer).

This print is based on the eighth image from the original series of forty-one paintings. The only change Lawrence made to this image while executing the screenprint was to add more blue to the background color.

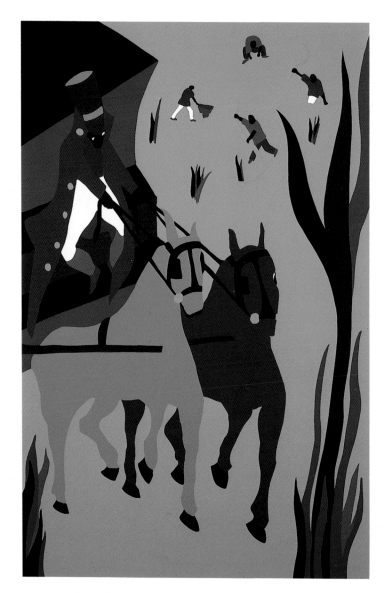

No. 8. In early manhood his seemingly good nature won for him the coachmanship for Bayou de Libertas, 1763. His job as coachman gave him time to think about how to fight slavery. He taught himself to read and to write.

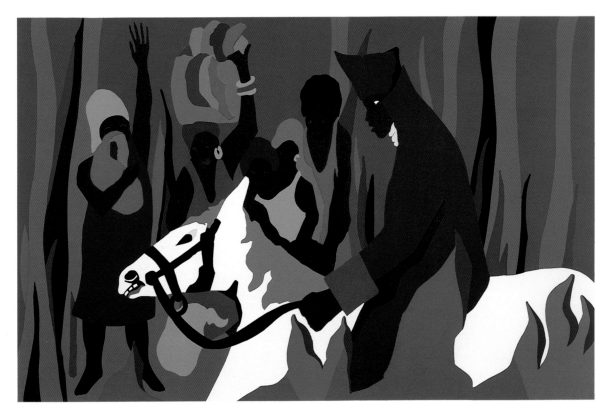

No. 16. Toussaint captured Dondon, a city in the center of Haiti, 1795.

Toussaint L'Ouverture series

92-2

Dondon

1992

Screenprint on Bainbridge 2-ply paper
From hand-cut film stencils
Edition of 124 with 15 AP, 8 PP, 7 WP, 4 CP
Screens destroyed
Image: 18⅜ × 28¼ (46.7 × 71.8)
Paper: 22 × 32 (55.9 × 81.3)

Signed and dated bottom right *Jacob Lawrence 92,* titled bottom center, numbered bottom left in pencil below the image; printer's chop mark bottom left.

Published by the Amistad Research Center, New Orleans, and Spradling-Ames, Key West, Florida; printed by Workshop, Inc., Washington, D.C. (Lou Stovall, master printer).

This print is based on the sixteenth image from the original series of forty-one paintings. Lawrence made several changes to this image while executing the screenprint: he increased the prominence of the foliage in the foreground, altered the form and features of the horse, and added red to the composition.

Toussaint L'Ouverture series

93-2

Contemplation
1993

Screenprint on Bainbridge 2-ply paper
From hand-cut film stencils
Edition of 120 with 14 AP, 8 PP, 3 HC, 3 WP, 4 CP
Screens destroyed
Image: 28⅜ × 18½ (72 × 47)
Paper: 32 × 22 (81.2 × 55.9)

Signed and dated bottom right *Jacob Lawrence 1/93*, titled bottom center, numbered bottom left in pencil below the image; printer's chop mark bottom left.

Published by the Amistad Research Center, New Orleans, and Spradling-Ames, Key West, Florida; printed by Workshop, Inc., Washington, D.C. (Lou Stovall, master printer).

This print is based on the twenty-seventh image from the original series of forty-one paintings. Lawrence made a number of changes to the image during execution of the screenprint. In the original painting, Toussaint wears a white shirt, the background is solid green, and the candle burns a yellow flame and drips no wax. There is no red in the original.

No. 27. Returning to private life as the commander and chief of the army, he saw to it that the country was well taken care of, and Haiti returned to prosperity. This was a very important period. He saw that people took care of their lands and cattle, and that slavery was abolished.

Selected Bibliography

Aesop's Fables. New York: Simon & Schuster, Windmill Books, 1970. Illustrations by Jacob Lawrence.

Genesis. New York: Limited Editions Club, 1990. King James version of the book of Genesis, illustrated with eight screenprints by Jacob Lawrence.

Brown, Milton W. *Jacob Lawrence*. New York: Whitney Museum of American Art, 1974.

Detroit Institute of Arts. *The Legend of John Brown*. Detroit: Detroit Institute of Arts, 1978.

Driskell, David C. *The Toussaint L'Ouverture Series by Jacob Lawrence*. New York: United Church Board for Homeland Ministries, 1982.

Everett, Gwen. *John Brown: One Man against Slavery*. New York: Rizzoli, 1993. With illustrations reproducing details of the John Brown series by Jacob Lawrence.

Hersey, John. *Hiroshima*. New York: Limited Editions Club, 1983. Poem by Robert Penn Warren and eight screenprints by Jacob Lawrence.

Hills, Patricia. "Jacob Lawrence as Pictorial Griot: The Harriet Tubman series," *American Art* 7 (Winter 1993):40–59.

Hughes, Langston. *One-Way Ticket*. New York: Alfred A. Knopf, 1948. Illustrations by Jacob Lawrence.

Lawrence, Jacob. *Harriet and the Promised Land*. New York: Simon & Schuster, 1993.

———. *Harriet and the Promised Land*. New York: Simon & Schuster, Windmill Books, 1968. Illustrations and text by Jacob Lawrence.

Powell, Richard J. *Jacob Lawrence*. New York: Rizzoli, 1992.

Saarinen, Aline L. *Jacob Lawrence*. New York: American Federation of Arts, 1960. Reprinted in David Shapiro, ed., *Social Realism as a Weapon*. New York: Frederick Ungar, 1973.

Turner, Elizabeth Hutton, ed. *Jacob Lawrence: The Migration Series*. Washington, D.C.: Phillips Collection, 1993. Introduction by Henry Louis Gates, Jr.; essays by Lonnie G. Bunch III and Spencer R. Crew, Deborah Willis, Jeffrey C. Stewart, Diane Tepfer, Patricia Hills, Elizabeth Steele, and Susana M. Halpine.

Wheat, Ellen Harkins. *Jacob Lawrence: American Painter*. Seattle: Seattle Art Museum and University of Washington Press, 1986. Essay by Patricia Hills.

———. *Jacob Lawrence: The Frederick Douglass and Harriet Tubman Series of 1938–1940*. Hampton, Va.: Hampton University Museum, 1991.